FOREVER ENGLAND

Forever England
by Liam Bailey
www.liambailey.com

First published in the United Kingdom in 2006 by
Dewi Lewis Publishing
8 Broomfield Road, Heaton Moor
Stockport SK4 4ND, England

www.dewilewispublishing.com

© 2006
for the photographs: Liam Bailey
for the text: Ally Ireson
for this edition: Dewi Lewis Publishing

ISBN: 1-904587-30-5

Design and Layout: Caroline Warhurst / Dewi Lewis Publishing
Print: EBS, Verona, Italy

Liam Bailey

FOREVER ENGLAND

photographs from Bekonscot model village

introduced by Ally Ireson

dewi lewis publishing

It all began in 1927.

Determined to find new ways to entertain his high society guests, London accountant, Roland Callingham, built a swimming pool alongside the tennis courts in his Beaconsfield garden. A year later he commissioned an outdoor model railway, the largest private one in the country. Now, when summer evenings grew too dark to play tennis, party guests could wander over to play with the model trains or swim in the pool.

His enthusiasm didn't stop there. No sooner had these additions been made than he and his head gardener began to build model houses to complement the railway, and two islands and a pier to add character to the pool.

It became a passion for Callingham. Encouraged by friends and staff alike, he planned a rural landscape to surround the pool, the railway and the rockeries around them. His team, including local schoolchildren, turned their hands to model making and the construction of Bekonscot town. Half-timbered and stone houses, shops and castles sprang out of the rockeries with a network of tiny roads connecting them. Everything was created from memory and photographs. This wasn't a project concerned with exactitude or reality, but an act of creation – eccentric, almost obsessive, and driven by an enormous sense of fun.

Fired by his own enthusiasm and that of friends and family, Callingham opened Bekonscot to the public in 1929, making it the first model village in the world. Members of his household staff, including his cook, his gardeners, his chauffeur and his maid, all helped him to run the village. No admission fee was charged, though the public were encouraged to put money in charity collection-boxes.

With its growing popularity, opening hours were extended from occasional days to weekend openings too. And for a while, there were open evenings when every building and path was lit up with tiny twinkling electric lights. As visitor numbers increased, paths were widened and more buildings were added. Over time Bekonscot's miniature kingdom grew to fill its 1.5 acre site with six little villages set in a landscape of farms and fields, castles and churches, woods, lakes and rolling hills. Its population also grew to 3,000 miniature people and 300 animals.

Roland Callingham died in 1961. Whilst some saw his creation as simply a folly, others fell under its spell and kept his dream alive.

Over 75 years and almost 14 million visitors later, Bekonscott stands as a tribute to English eccentricity, humour, determination and craftsmanship. It remains firmly rooted in its idyllic 1930s timewarp, stubbornly refusing to modernise. It has never aged and has never really grown up. It remains a wondrous place – a land of the imagination, where life is simple, secure, unchanging – a little piece of history that is forever England.

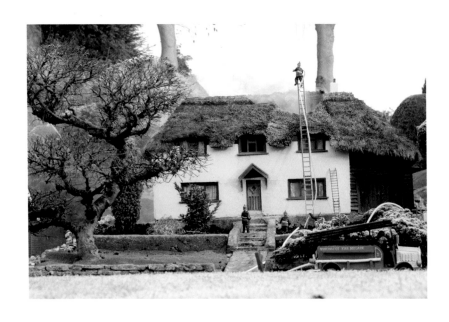

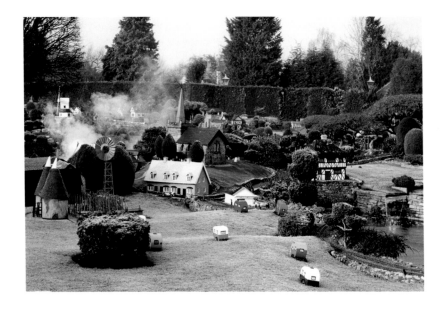

This Modern Fairyland

Off a quiet residential road in a Buckinghamshire commuter town – the kind of place where curiosity gets frustrated by high fences, long front paths and strategically placed conifers – a pair of green metal gates mark an entrance. Inside, a gravel path and well behaved hedges suggest you've arrived in an upscale garden centre. But walk through a doorway in a stockade-like fence and you find not plants but a fragile little world where the rules of scale have, very politely, been broken. The ground, flat as a Monopoly board outside, has bubbled up into a system of miniature hills, lawns and valleys, creating a landscape as soft as a bowl of gently melting ice cream. Studding the greenery are trees and bushes that come up only as high as your waist, buildings whose windows stare at your shins, and an entire society of people, each of whom would be out of their depth in your coat pocket.

Bekonscot Model Village is strange to look at but almost immediately feels familiar. Probably this is because its rolling green landscape – punctuated by passing steam trains, church spires, thatched and Victorian-style cottages, red phone boxes, country pubs, a tea room, a cricket pitch, a rash of white picket fences, and so on – looks like an impossible collage of the outdated yet default symbols of England most of us instinctively recognise, and which tourist-board marketing departments seem in no hurry to replace. Although we might dismiss the contemporary relevance of the scenes at Bekonscot they retain a sure-fire emotional charge. Added potency is given to this button-pressing vision of the past by the model village's rule of painstaking uniformity: everything its inhabitants do, wear and eat is strictly modelled on life in the 1930s – in this tiny pre-war world there are no anomalies to snag the eye.

Like all model villages (there are still about 20 open to the public in the UK), Bekonscot relies on a straightforward yet compelling formula: it makes us into giants and lets us walk around a series of fragile scenes, inviting us to look, without fear of causing offence, at the intimate details of other people's lives. Zapped down to an impossible scale, these tiny relationships, activities and objects seem somehow magical, turning most of us into mesmerised literalists: 'Look! They're swimming in the pool!'

A big part of Bekonscot's particular appeal is that it shows us such a complete and highly ordered society: everyone here has a role, even if it's just to enjoy a cheeky fag by the side of the canal. And although there are signs of real-world disorder, all have been turned into gentle jokes: a tiny Ealing-comedy policeman tries to apprehend a tiny thief who is sprinting away from the racecourse with a stolen

bag; a ladder made of knotted sheets hangs out of a window at the prison; and a thatched roof burns, but is permanently attended by a well-equipped fire crew. As you make your way along the narrow paths that loop through the model village like concrete tagliatelle, everything you notice, even the lame puns (a large set that includes stock in trades such as 'Chris P. Lettis – Fruiterers & Grocers'), seems deliciously benign. But probably the most appealing thing about Bekonscot, which opened in 1929, is the idea that the members of this little community have been living and working here together, unchanged, for an entire lifetime.

It is the staging and individualisation of Bekonscot's miniature human beings that really mark the place out. Nearly all of the 3,000 plus characters seem frozen in a moment from a very real-seeming and often subtle scenario: the elation of the centre forward who's just stuck a ball in the back of the net, the vicar trying to enthuse a potential parishoner, the woman neatly waiting for a front door to be answered. It is this emotive quality that prompted photographer Liam Bailey to document the lives of Bekonscot's inhabitants.

Working always before the gates opened to the public, Bailey created a series of images of Bekonscot's figures that although unstaged were approached in the manner of formal portraits. The results are unexpected. The images take us far closer to the characters than communal etiquette, our physical size and the polite boundaries of the model village allow, isolating small groups and individuals who are often almost unrecognisable as the tiny figures who populate the shrunk-to-fit aerodrome, harbour or nunnery. Suddenly, the concrete discrepancy between them and us is lost and we are made to share their scale, seeming to hover behind them on the street or next to their faces as they take a turn on the Ferris wheel. Bailey thinks of the work as 'social documentary' (and, in the sense that he is shooting people incapable of self-consciousness, the 'perfect' documentary project), and cumulatively the images build a convincing portrait of the life of a particular community, one that often focuses on the experience of its more unremarkable members.

All life, albeit a highly edited version, is certainly here. Bailey comprehensively documents – and celebrates – the impressive sweep of Bekonscot's social scenarios, which range from a trade unionist addressing a miners' meeting to a party of smartly dressed passengers about to board a private plane. But in the pictures, as in the model village, it is the lives of working men that stand out. They show us a catalogue of jobs with a strong physical focus: car mechanic, fisherman, canal-boatman, delivery man, miner, woodcutter, driver, burger seller, farmer, and so on. Again, as with Bekonscot's rolling landscape, there is an emotional charge here, a tangled nostalgia, perhaps, for an era when it was far easier to judge an honest day's work.

Bailey's images stay very close to their subjects; often uncomfortably close. Although he had already begun to see the sadness in some of the model village's scenes, he was himself surprised at how unsettling some of the images can be – many brim with ambivalence. In places, the characters' fixed roles begin to look less like cosy destiny and more like a heavy burden: the man running from a furious bull, head jerked back over his shoulder in perpetual panic; the fairground performer on the knife-thrower's wheel, head stuck at five o'clock; the empty-faced girls sitting on adjacent swings like characters from a Beckett play, wires across their laps.

This ambivalence is appropriate, as Bekonscot is itself not what it seems. Its little community hasn't been eating picnics, gossiping on street corners and drinking pints, come rain or shine, since 1929. Time hasn't stood still; it has been wound back. In 1992, driven in part by the fact that nostalgia sells, Bekonscot's directors made the decision to erase all the signs of contemporary life that had been allowed to seep into Bekonscot during the 1960s and '70s (including a miniature Concorde on a concrete runway). And as time hasn't stood still in the model village, neither in fact have its inhabitants: roughly a quarter of its scenes are moved around each year to create the illusion for returning visitors of there being something they had missed, and all movable parts (buildings included) winter in sheds from November to January. The figures, whose resin body parts often only last for just three or four seasons, are routinely replaced, and many are unplugged each week so the gardeners can cut the grass. These facts make Bailey's images all the more poignant because, in part, they collude with the cosy fantasy at the heart of Bekonscot: that its community enjoys a state of unchanging togetherness.

But, as Bailey's obvious affection for the people of Bekonscot proves, it's not always the facts that count. Even if technically the model village is more a 'Modern Fairyland' (a phrase used in Bekonscot's original adverts) than 'A Little Piece of History That is Forever England' (a current marketing slogan), then where is the harm? In common with most attempts to show us what England is, Bekonscot offers few straight answers. Maybe the closest it can get is in the sight if offers us, seven days a week, of groups of politely enthusiastic visitors walking in a semi-orderly fashion round an eccentric suburban garden, enjoying the chance to look without embarrassment into a series of strangely public lives – lives that Liam Bailey's intimate portraits allow us to see are as full of grey areas as our own.

Ally Ireson

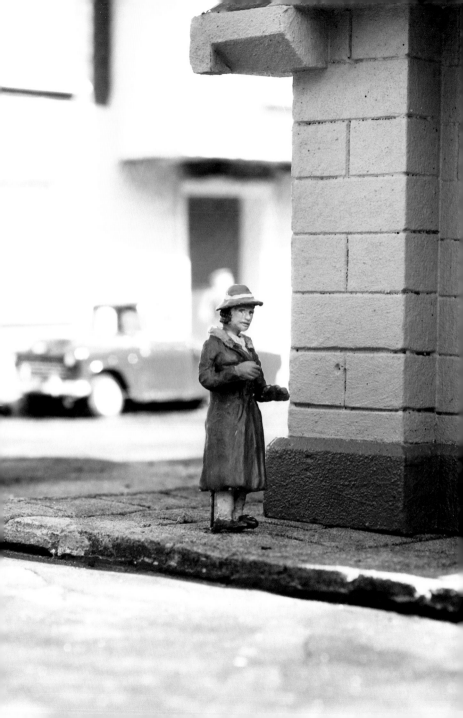

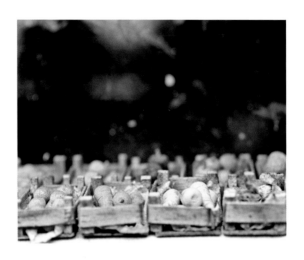

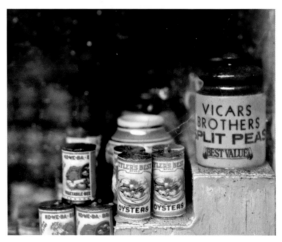

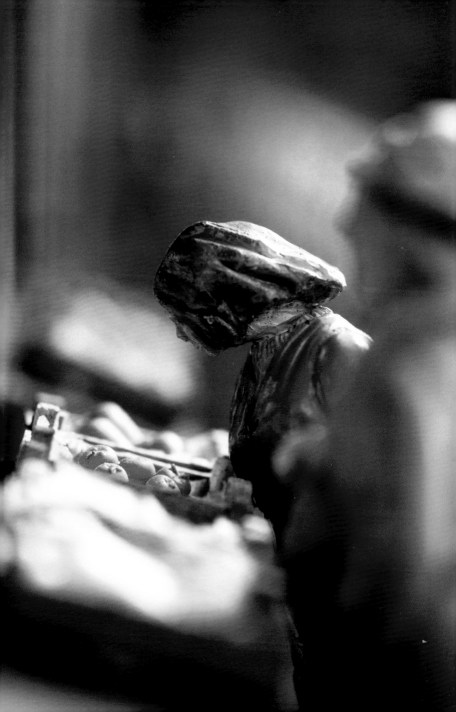

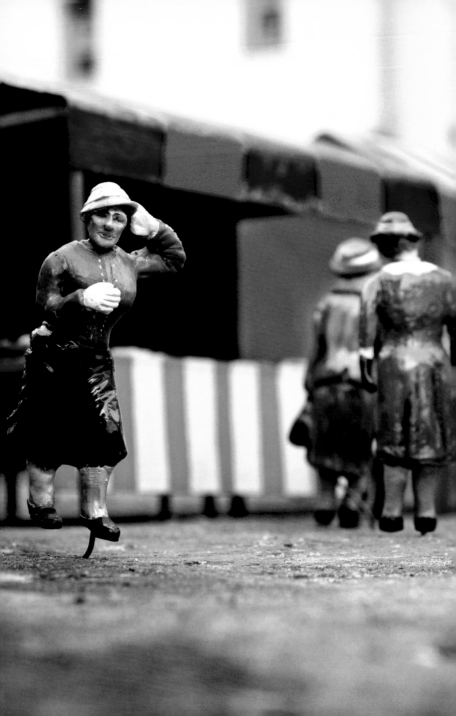

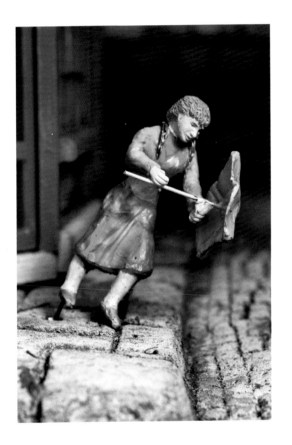

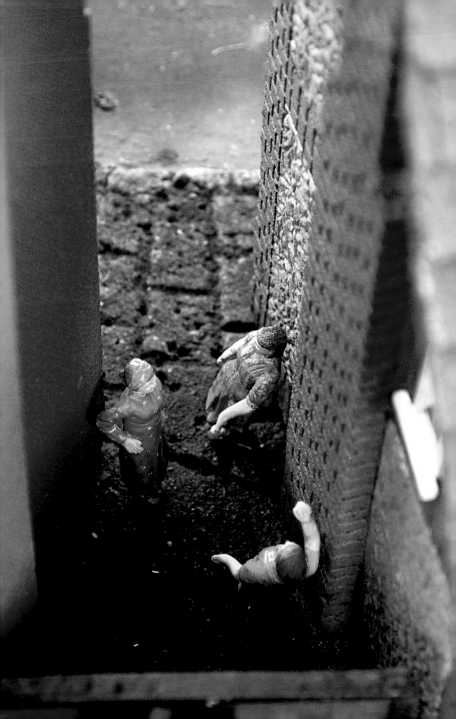

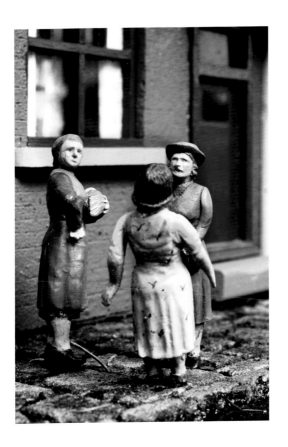

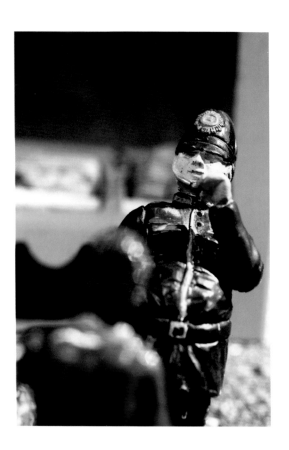

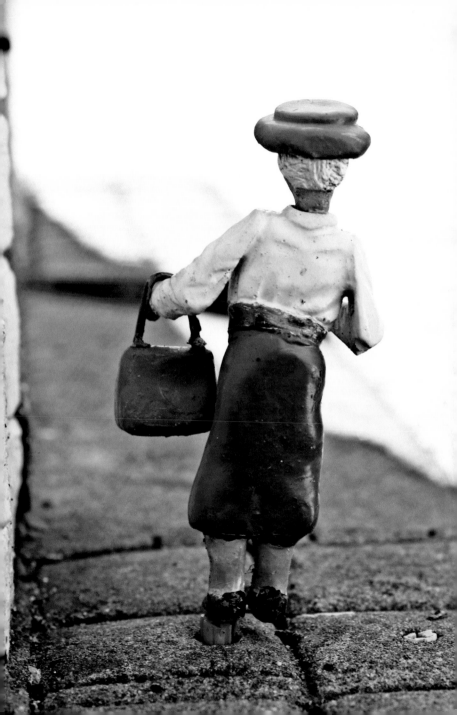

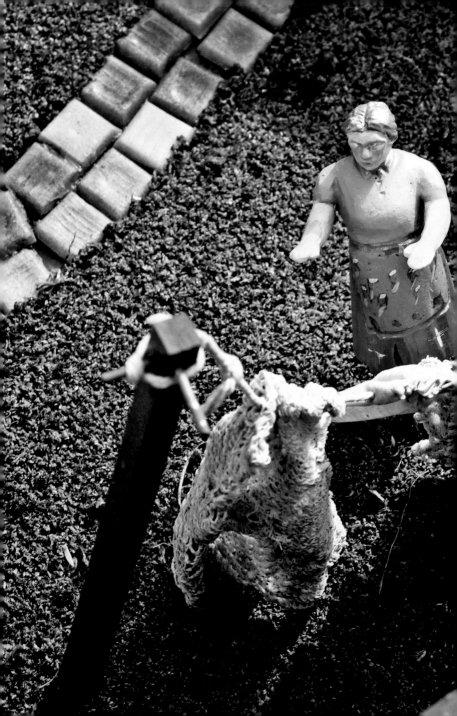

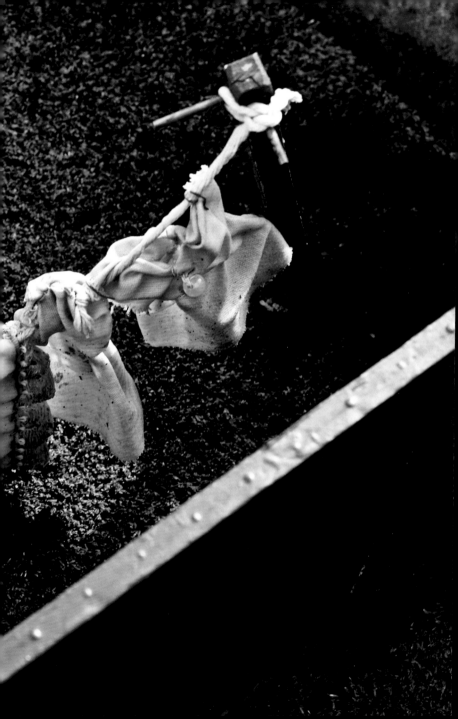

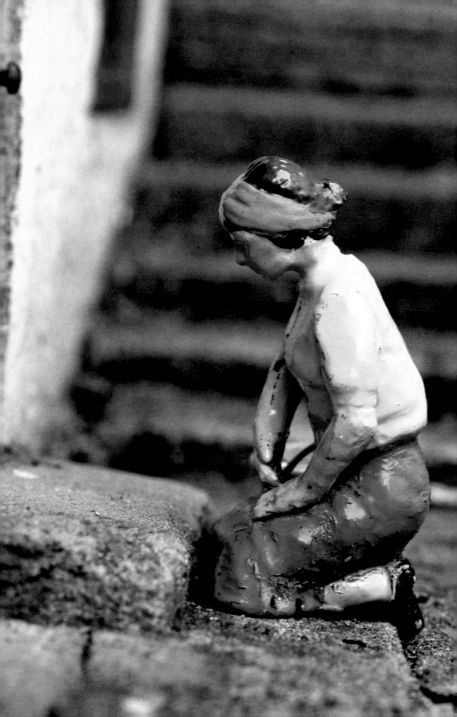

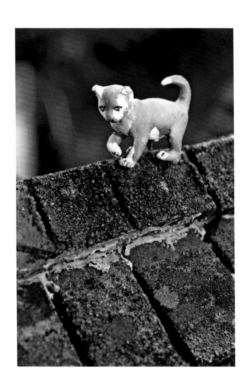

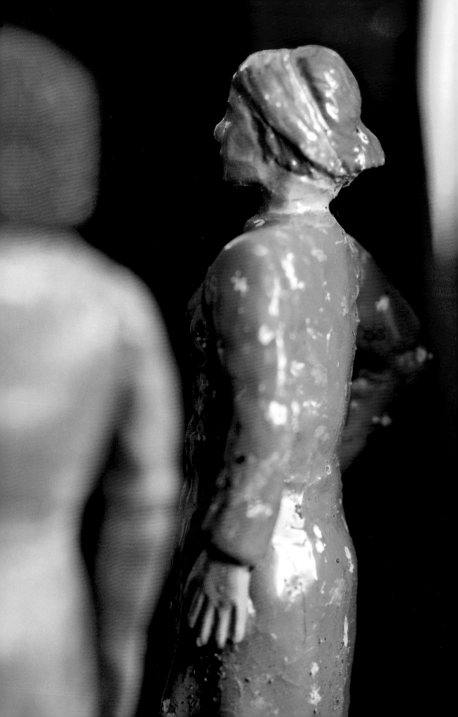

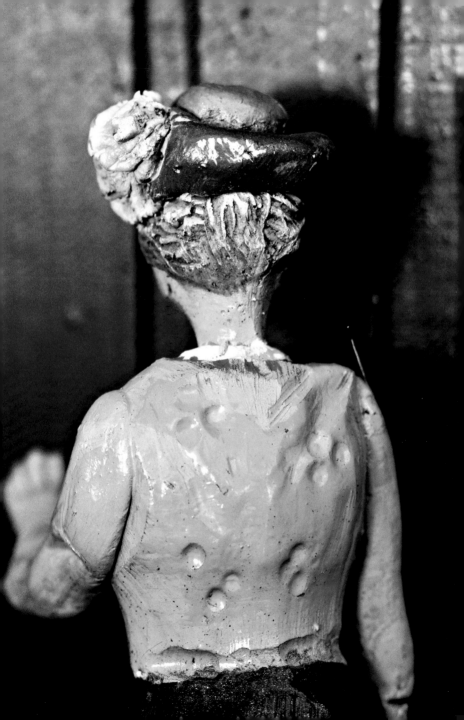

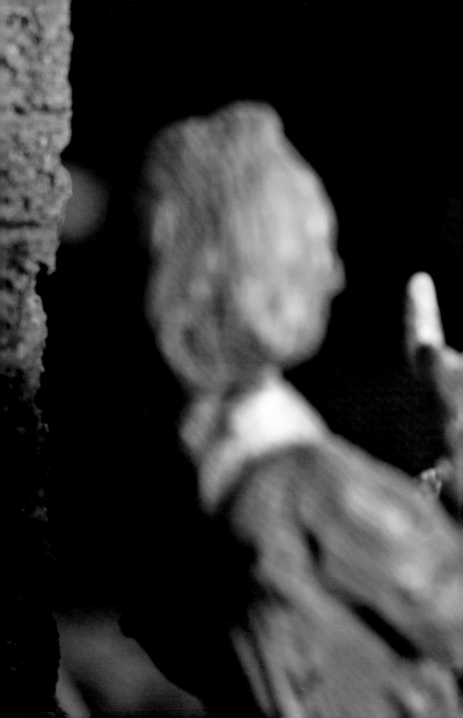

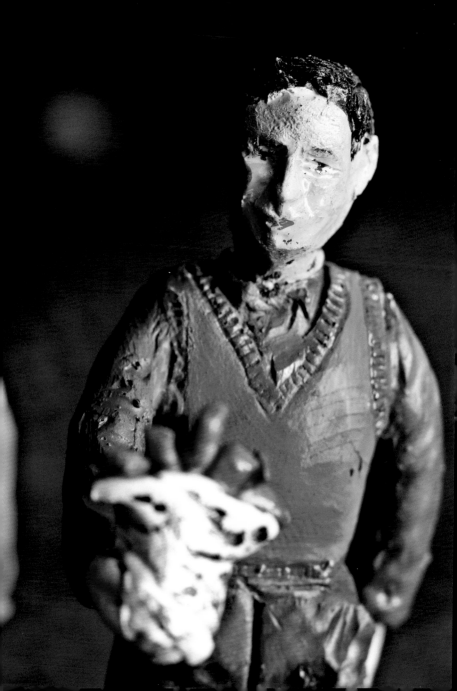

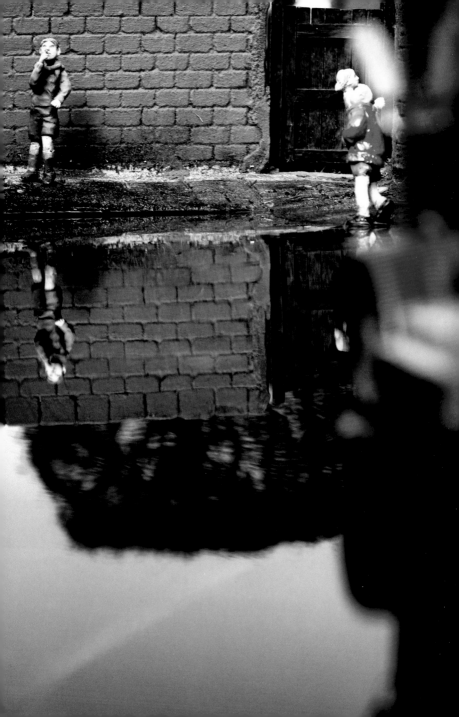

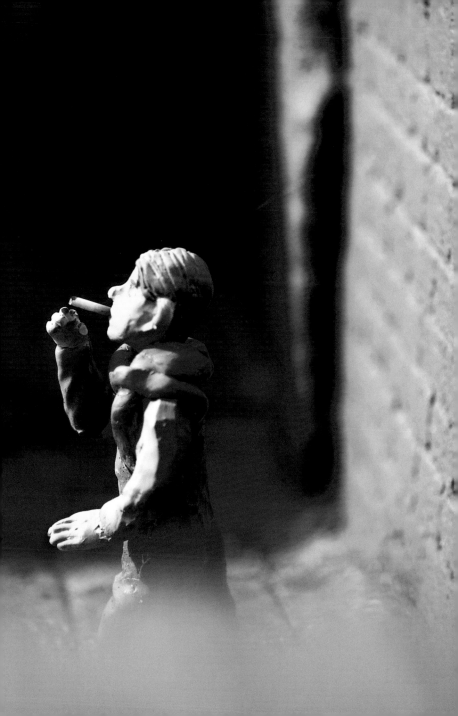

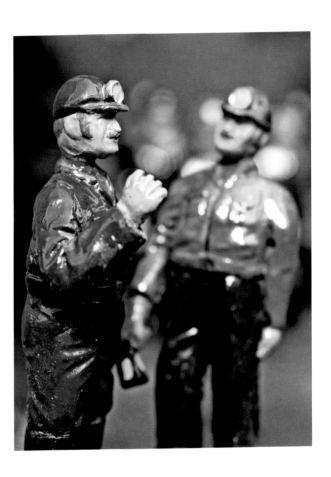

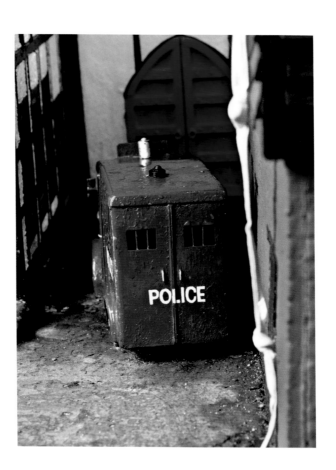

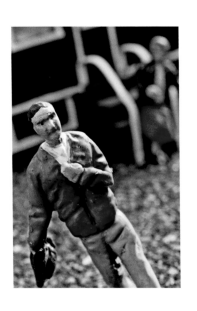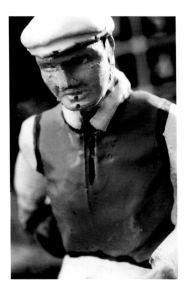

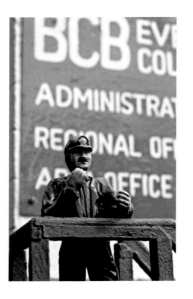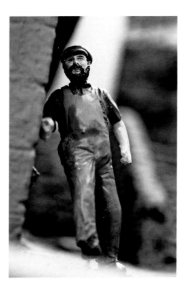

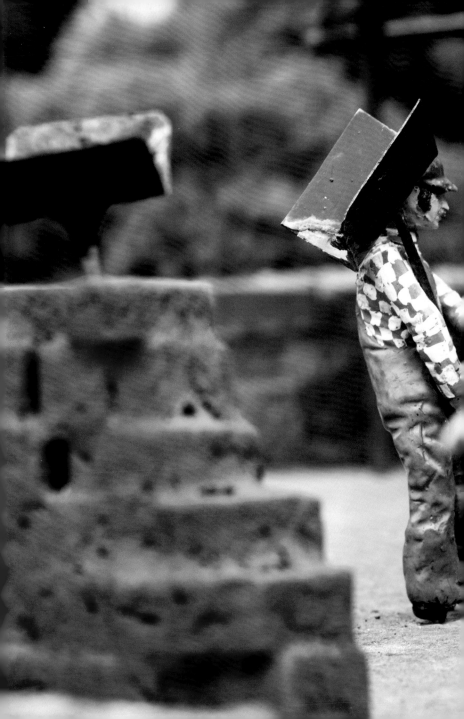

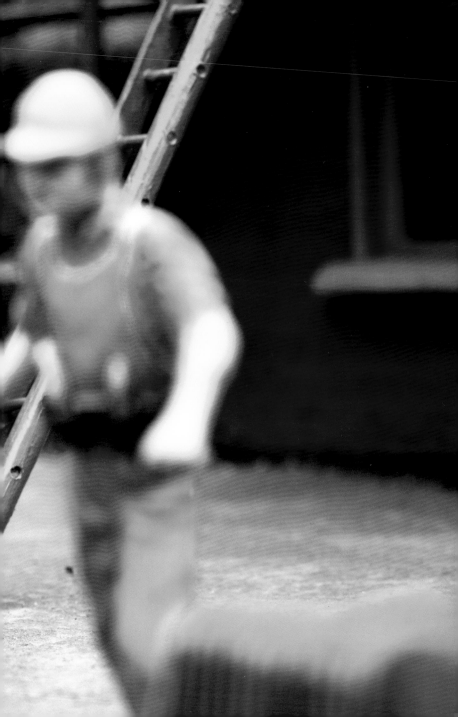

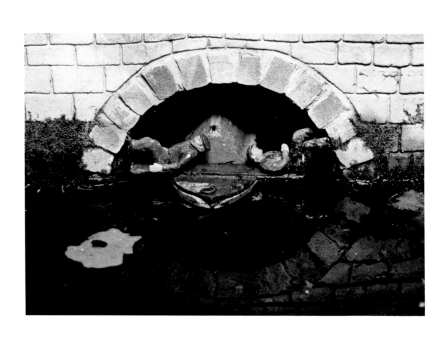

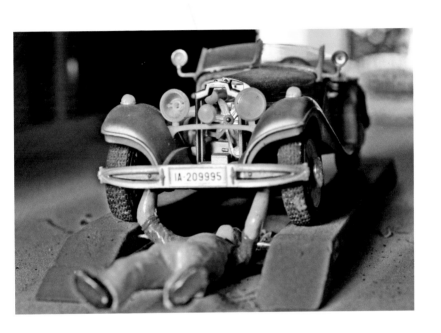

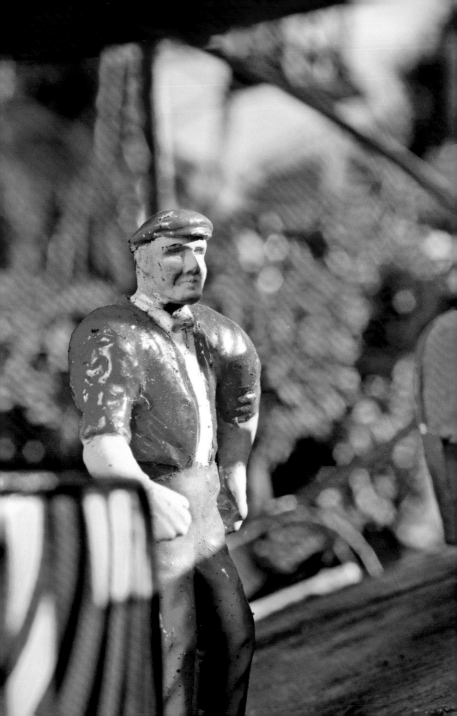

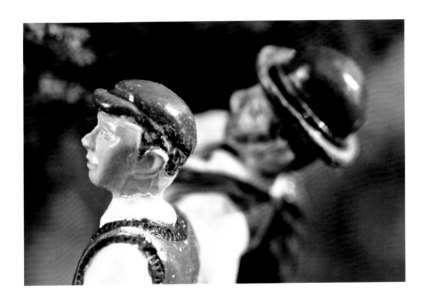

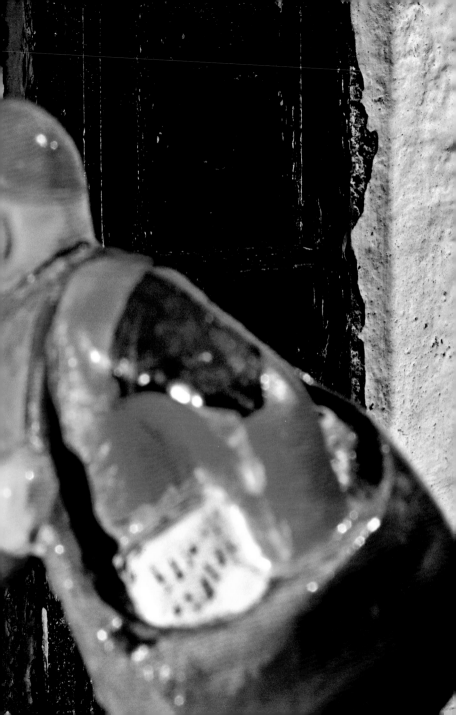

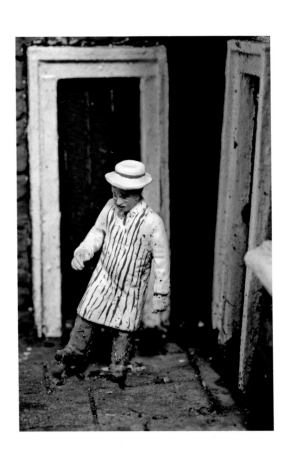

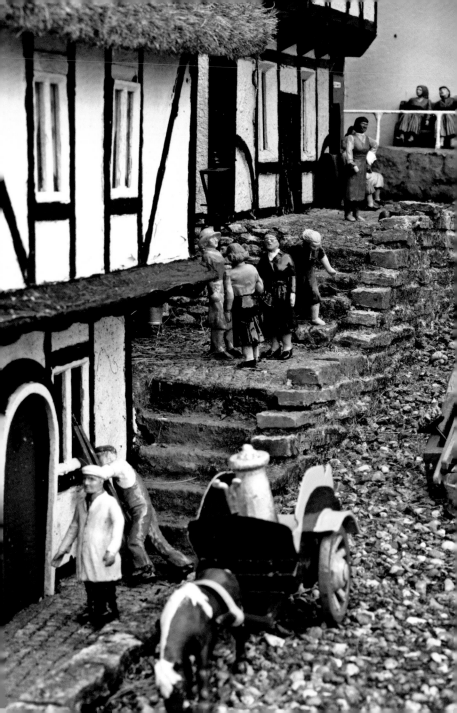

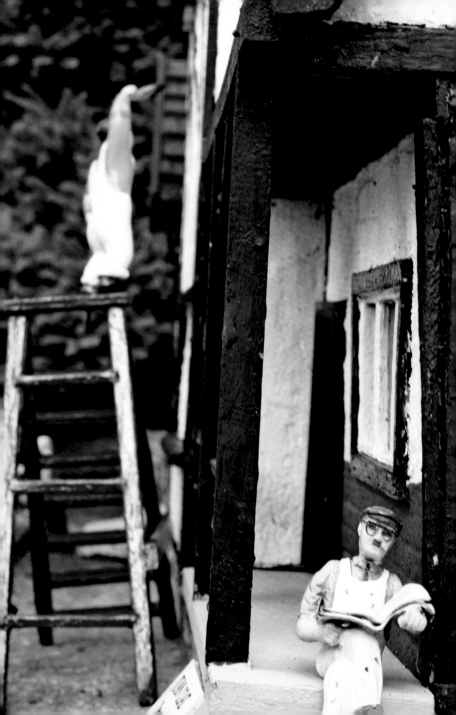

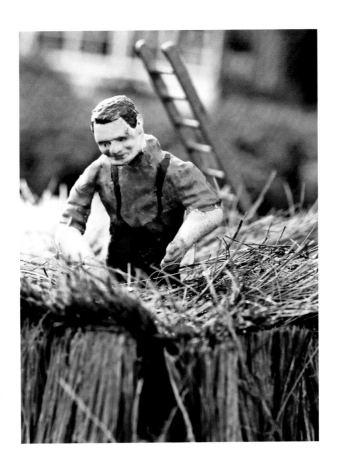

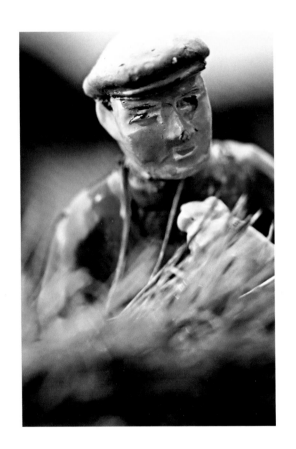

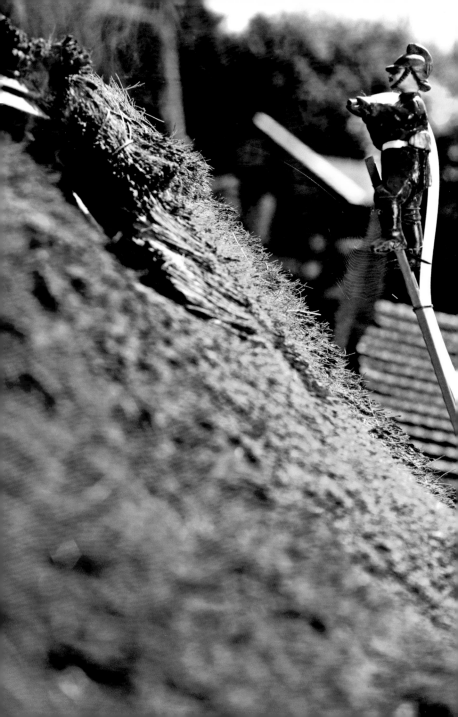

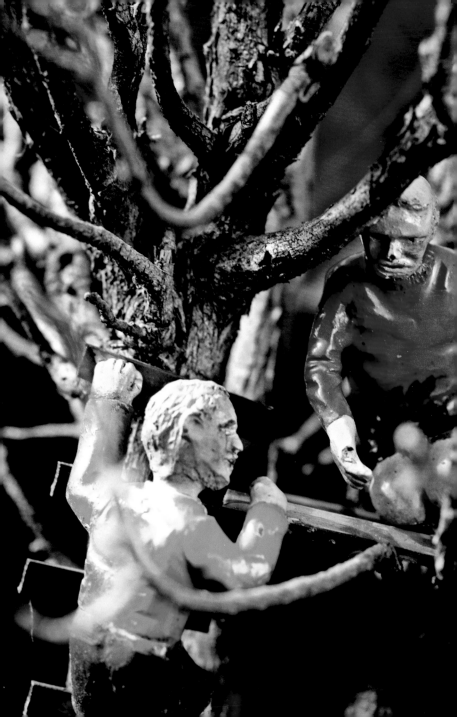

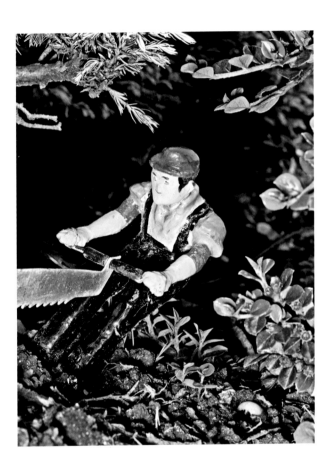

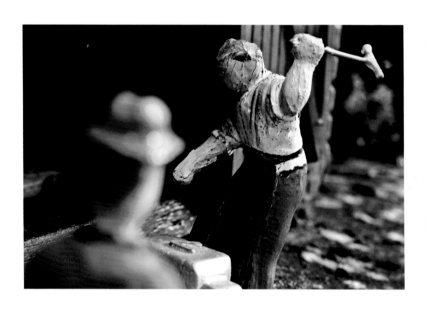

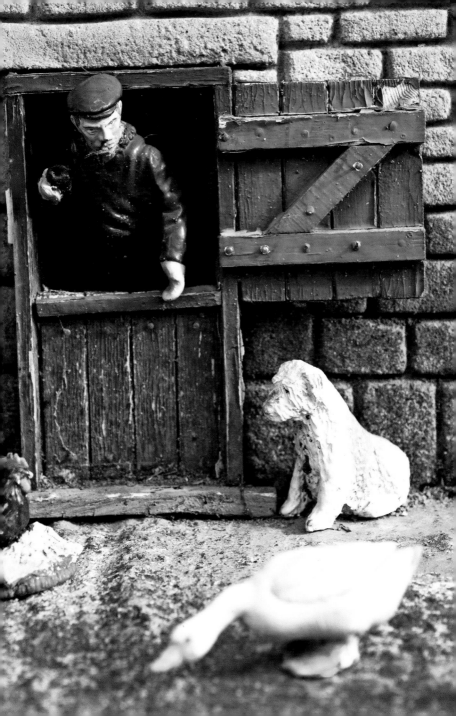

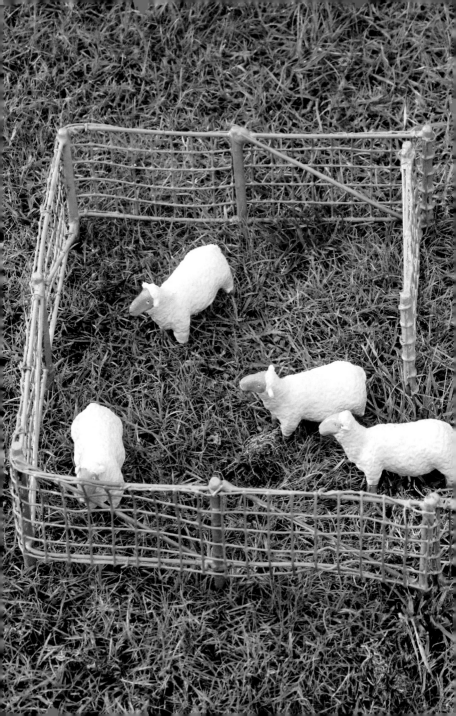

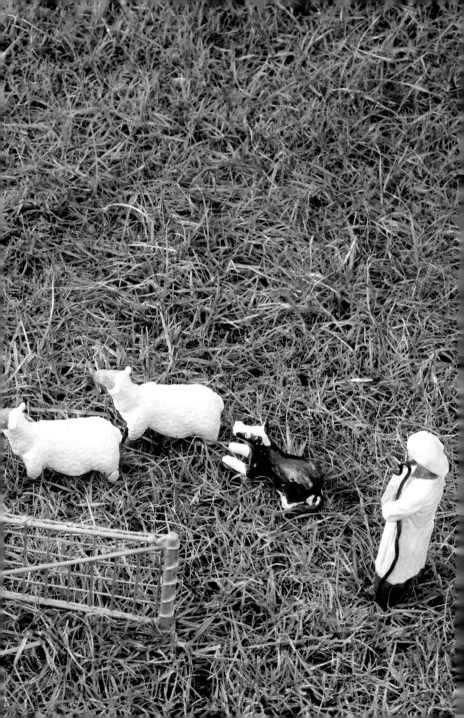

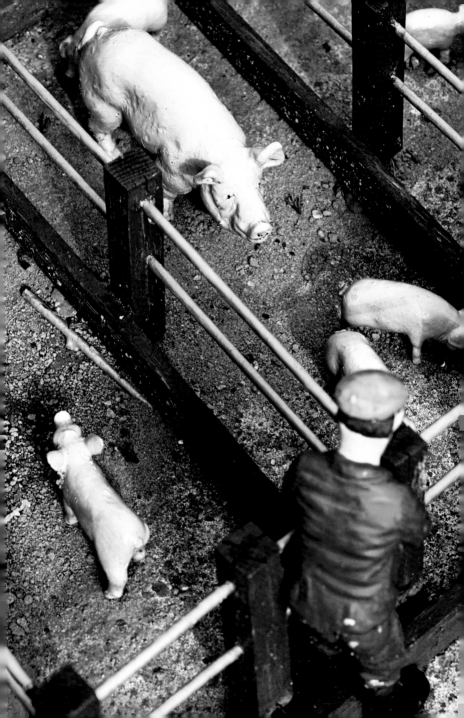

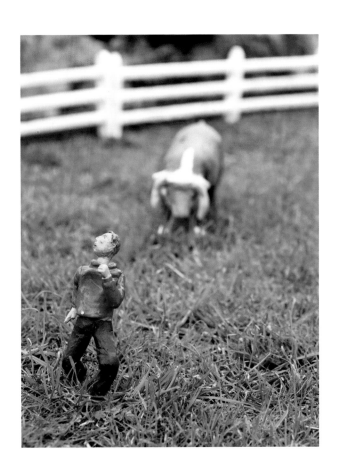

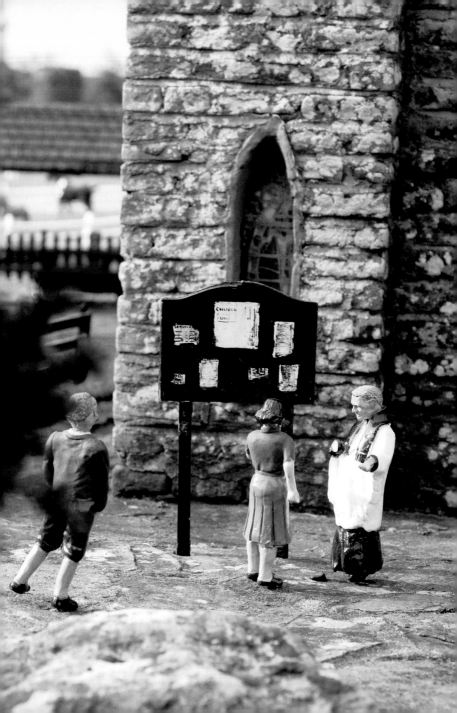

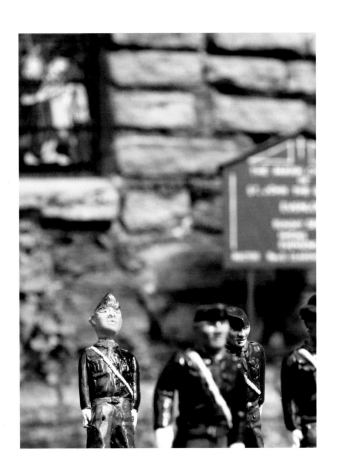

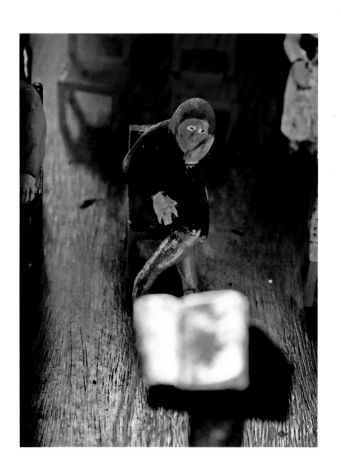

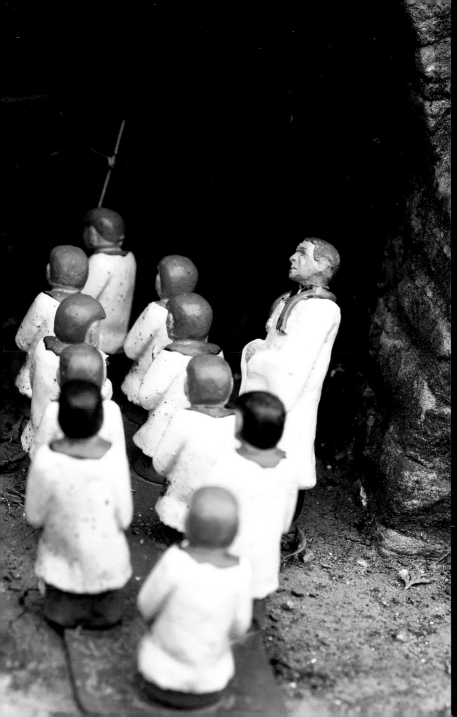

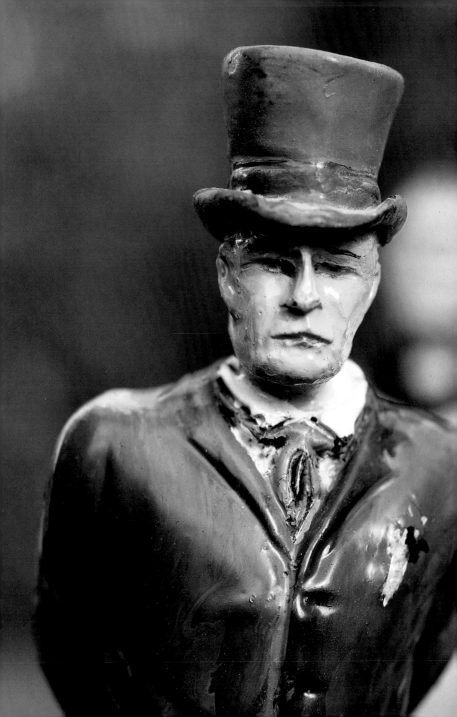

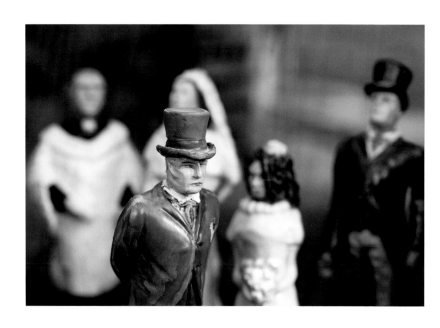

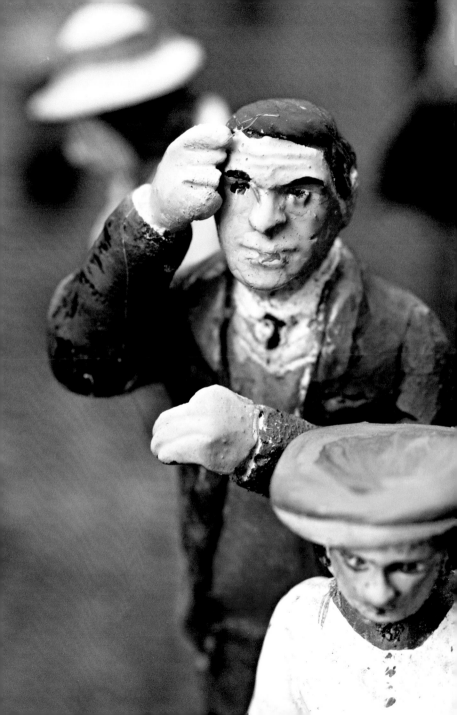

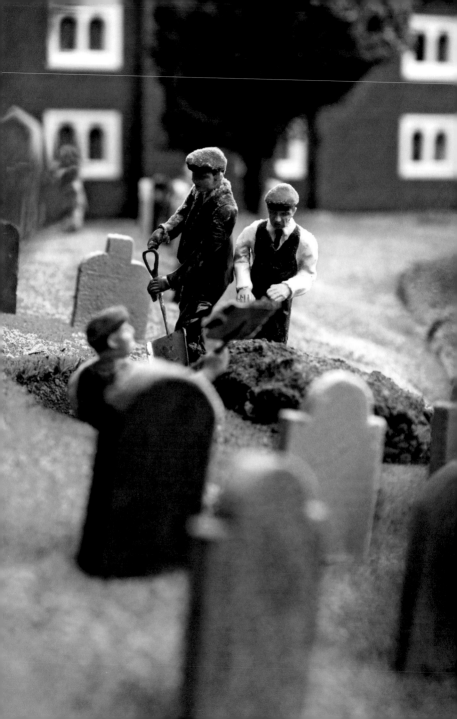

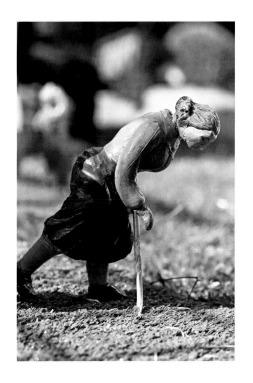

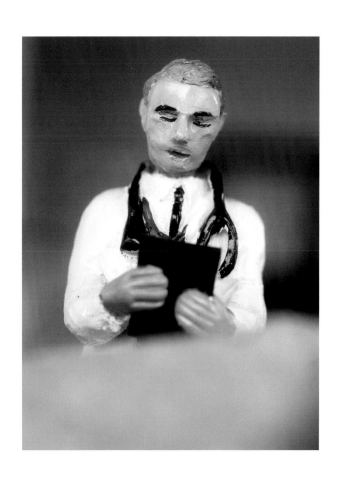

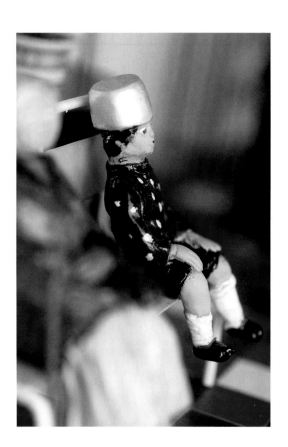

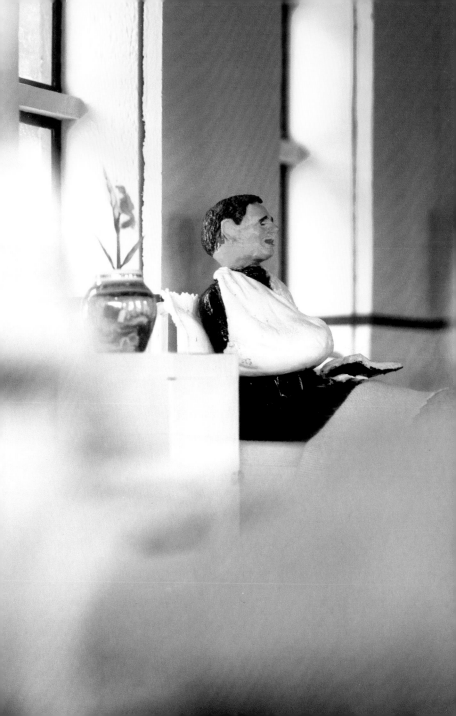

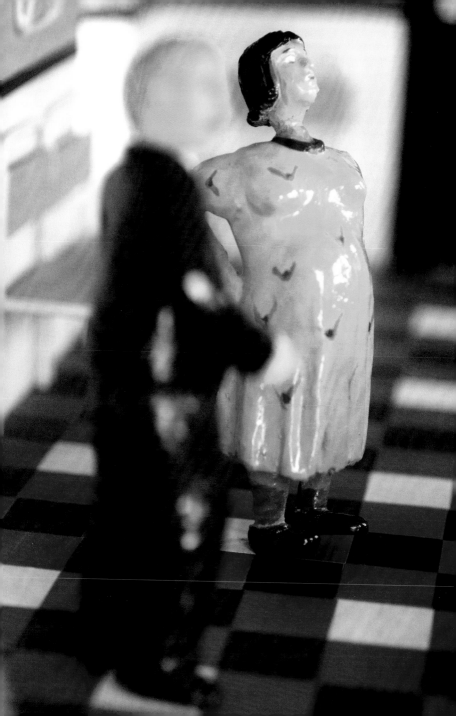

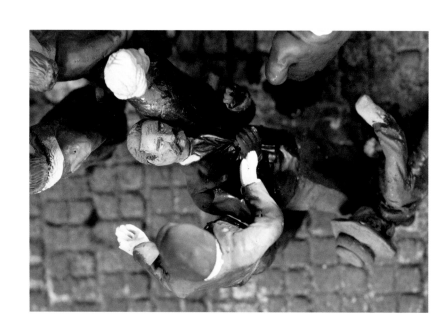

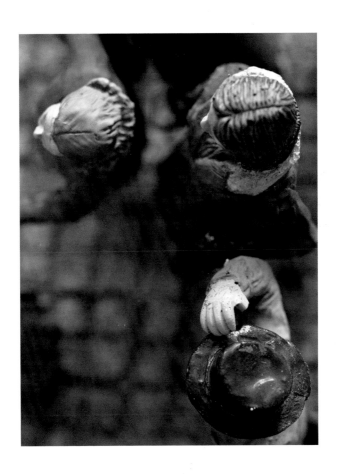

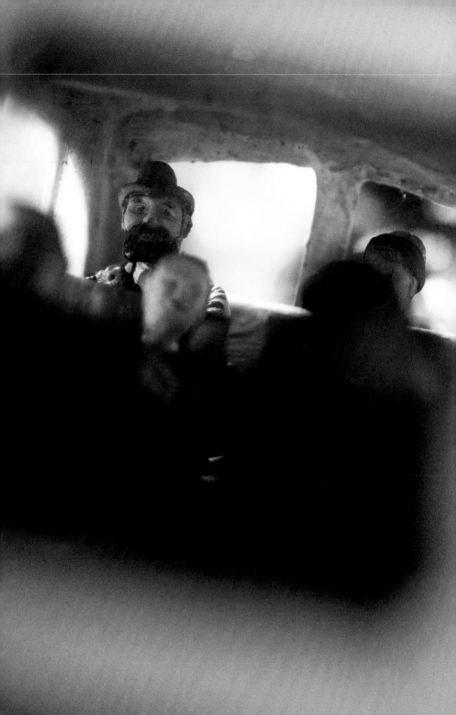

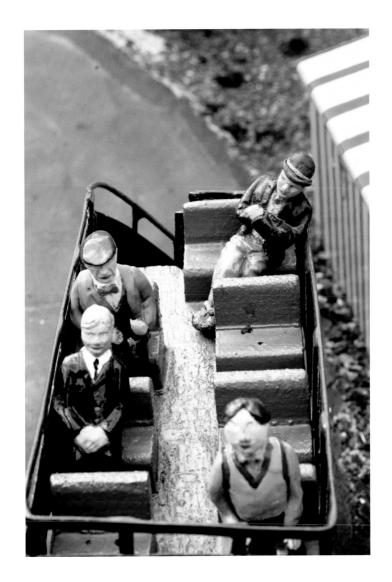

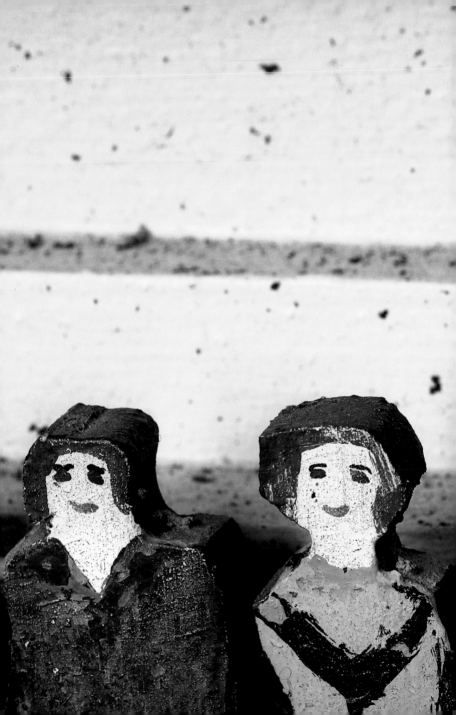

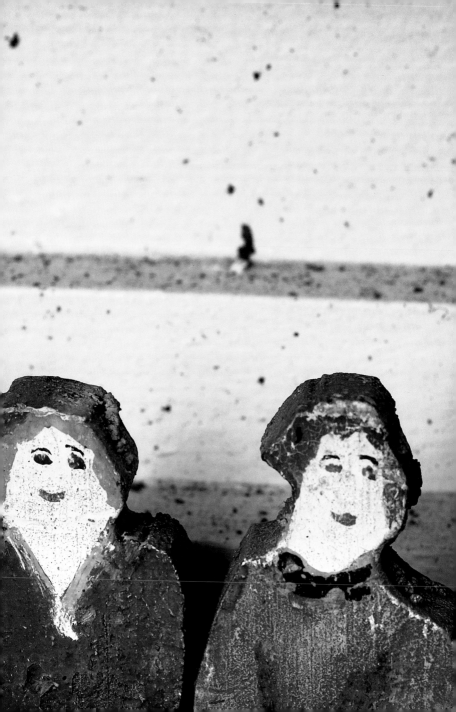

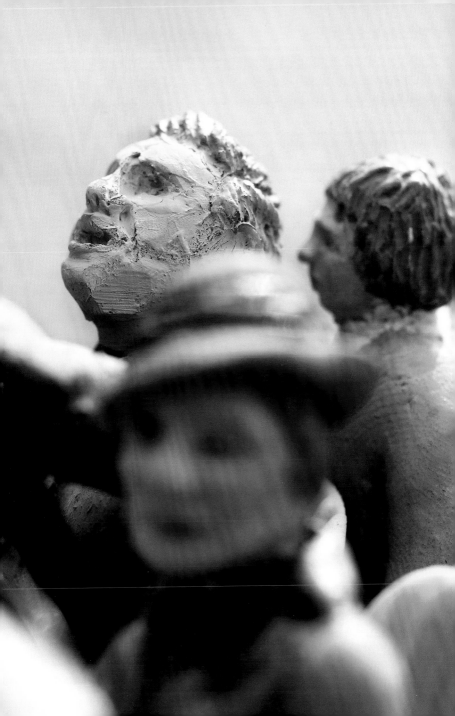

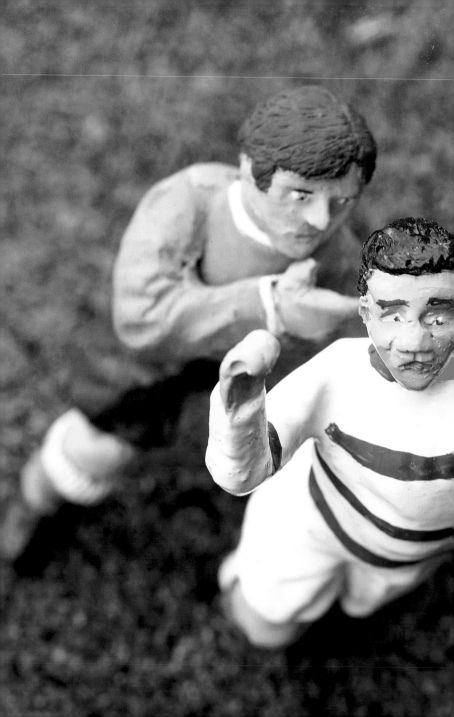

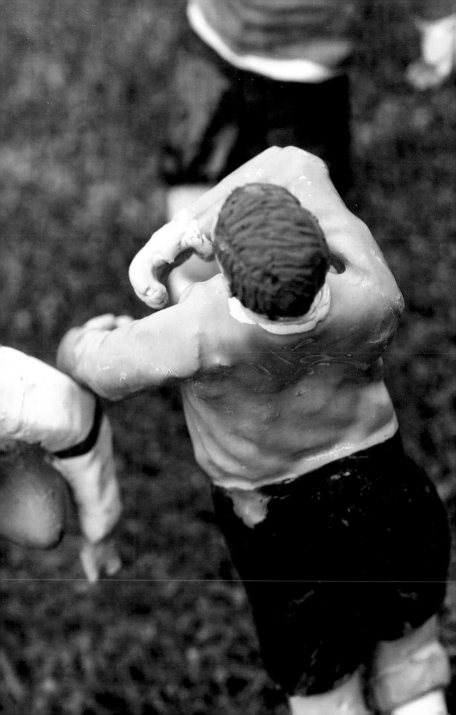

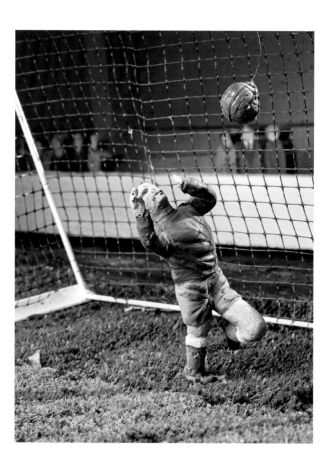

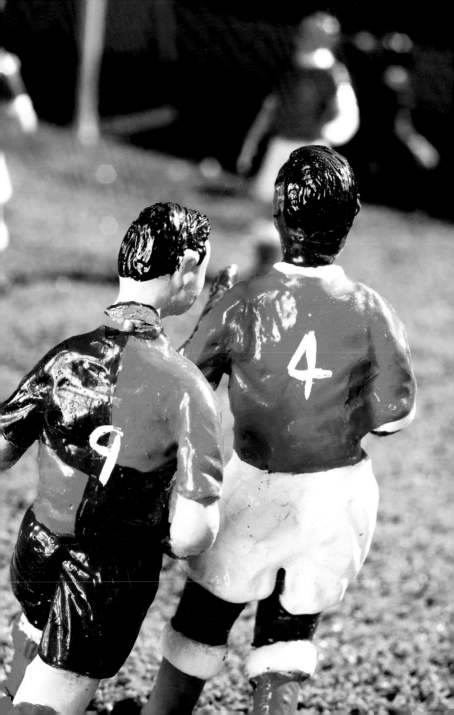

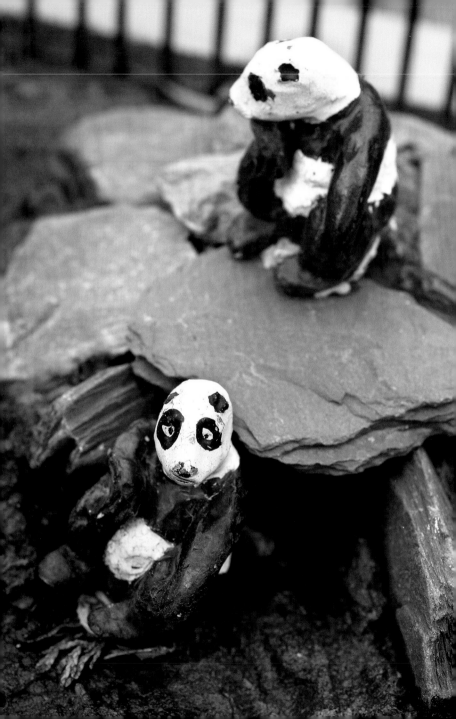

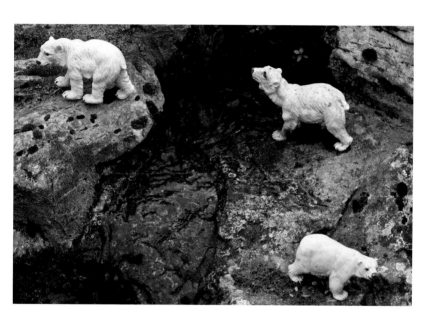

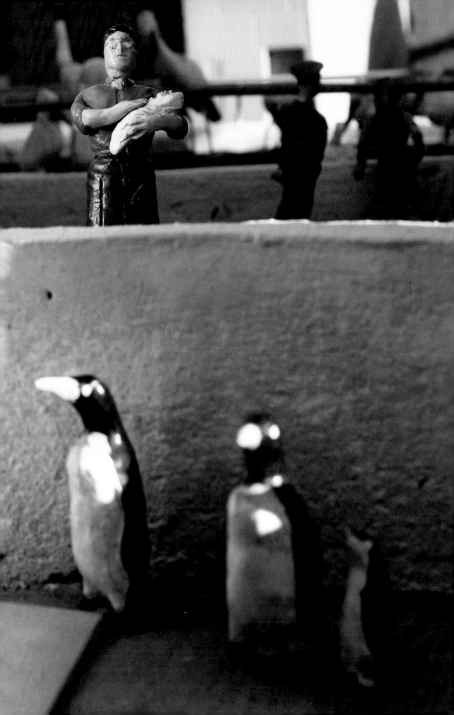

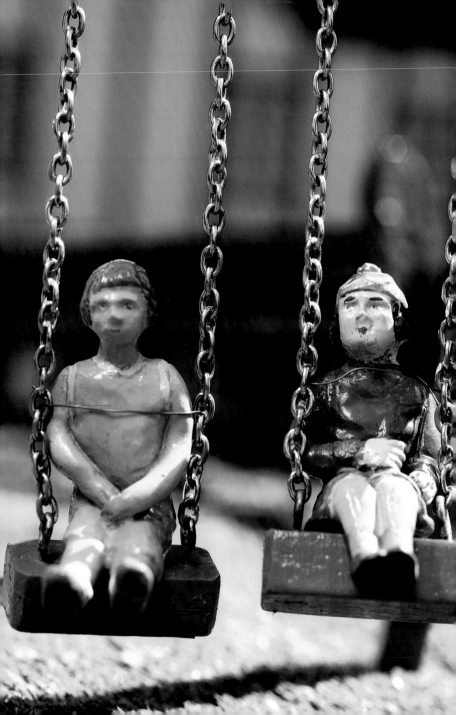

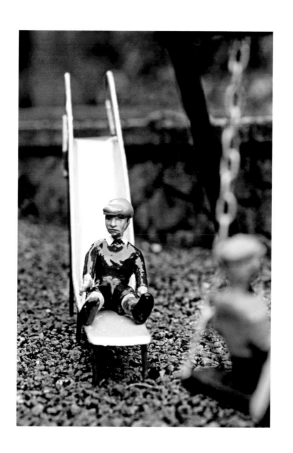

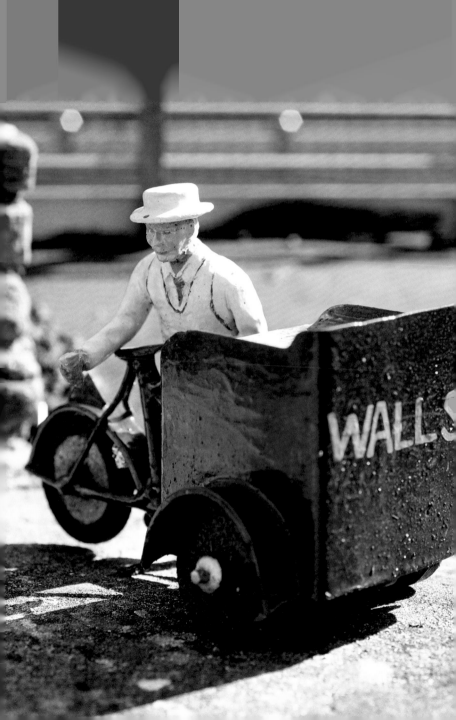

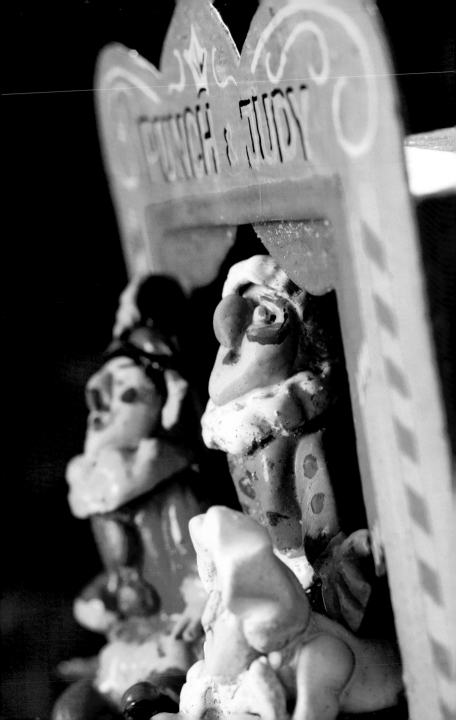

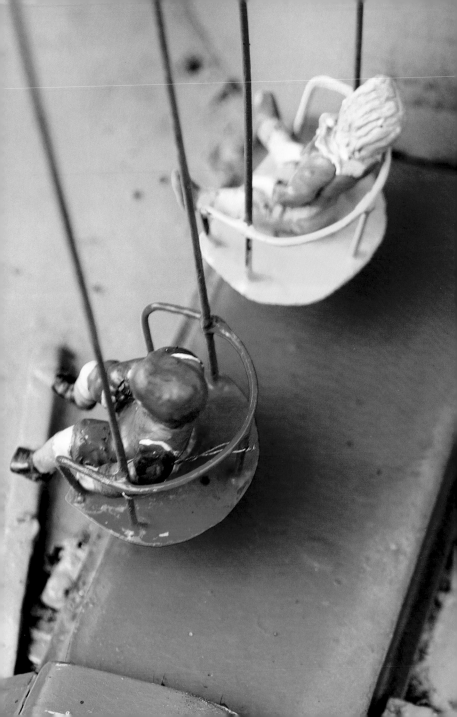

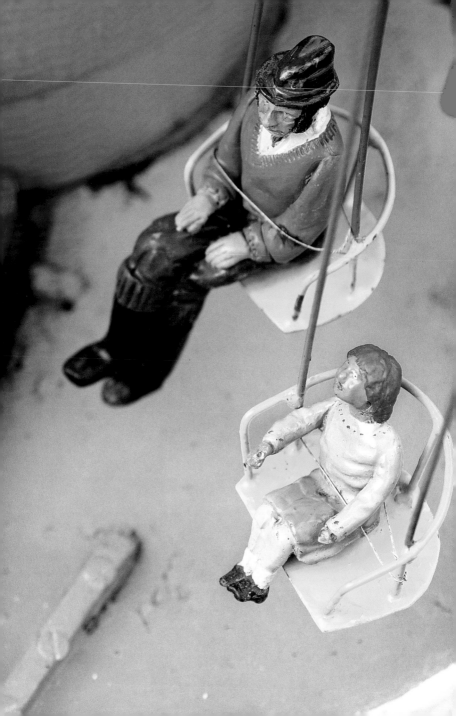

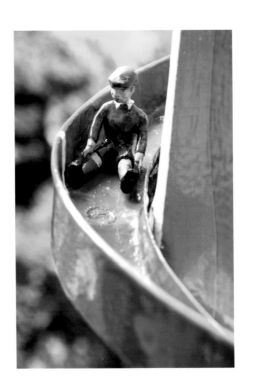

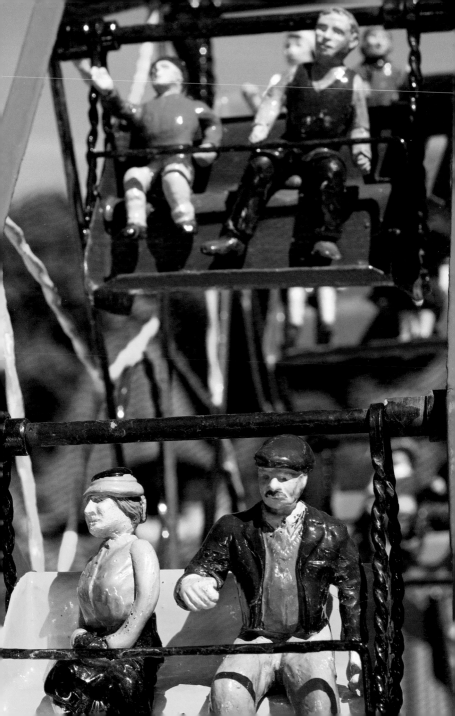

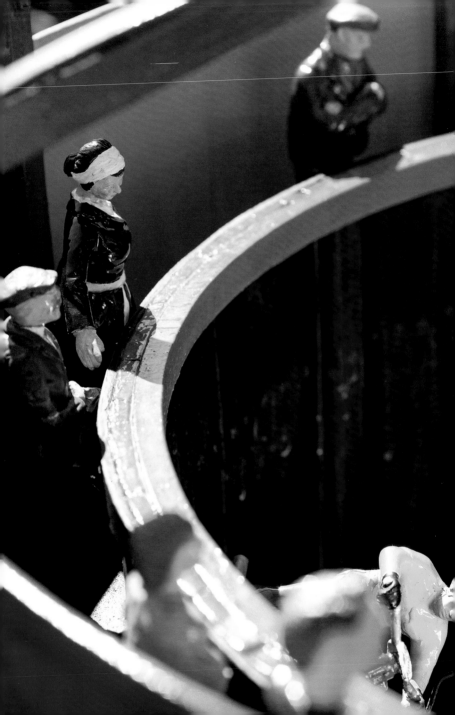

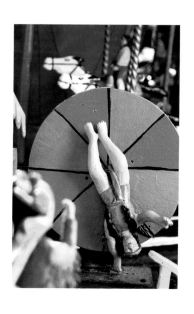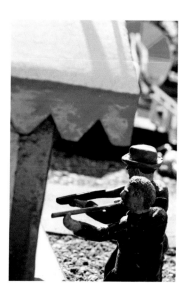

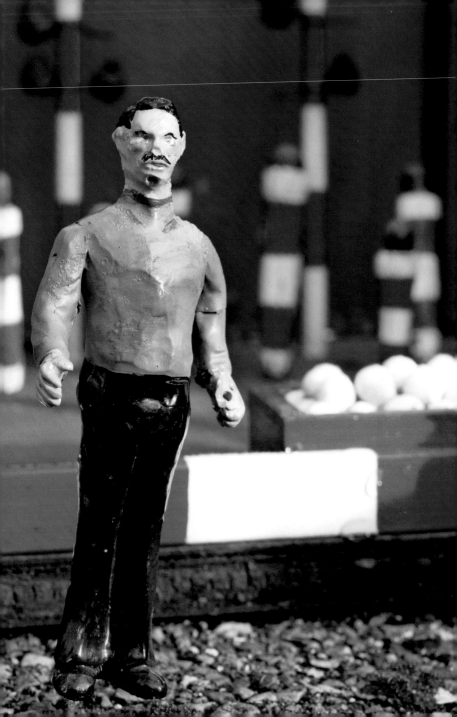

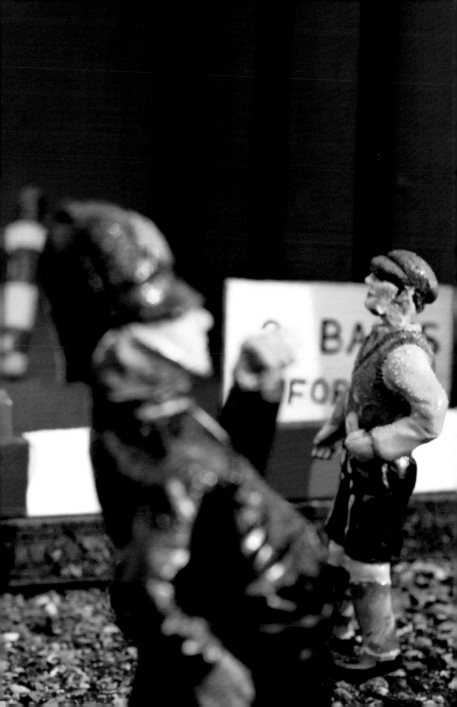

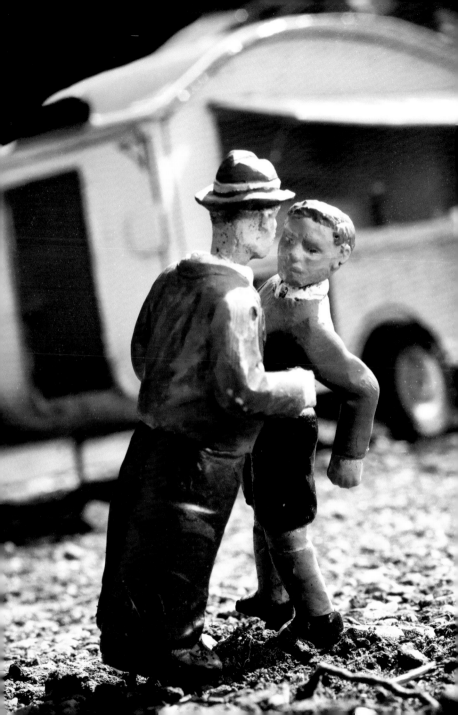

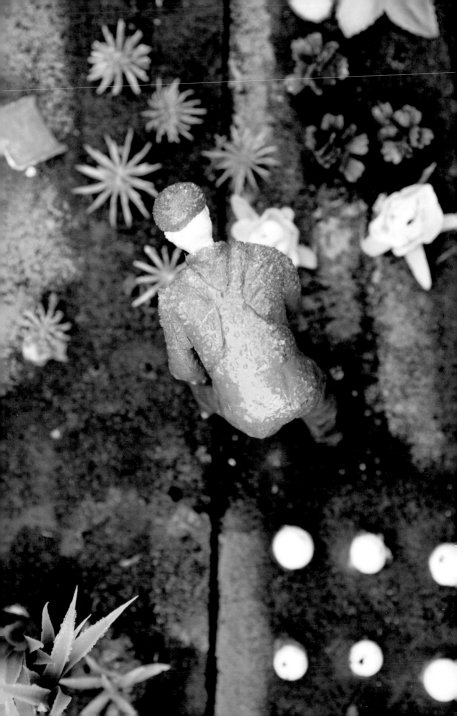

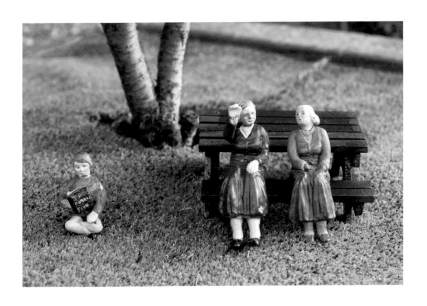

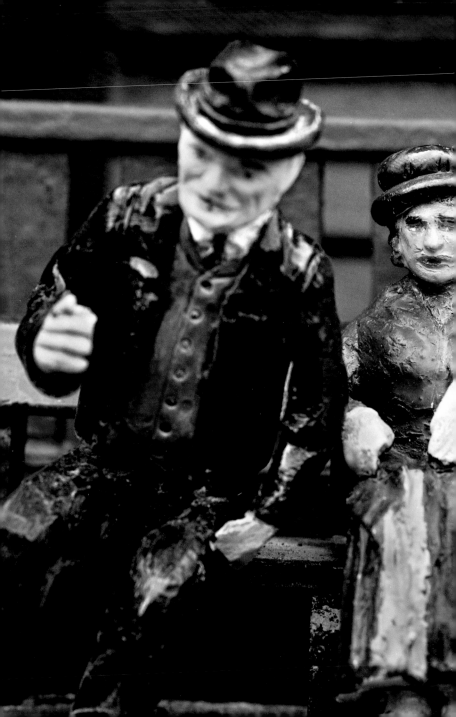

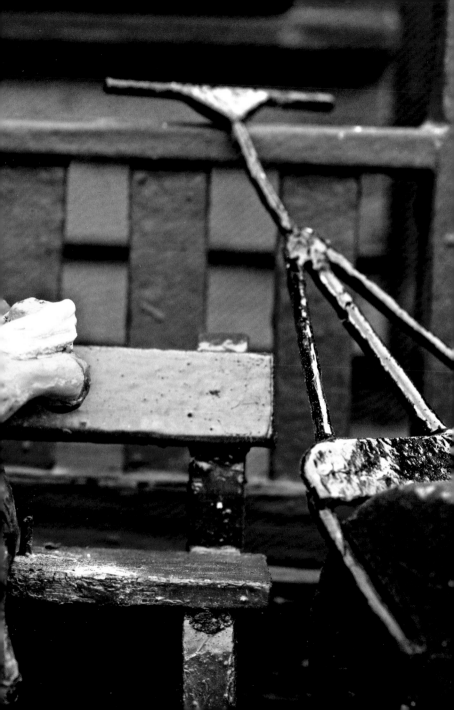

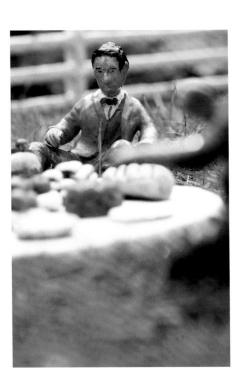

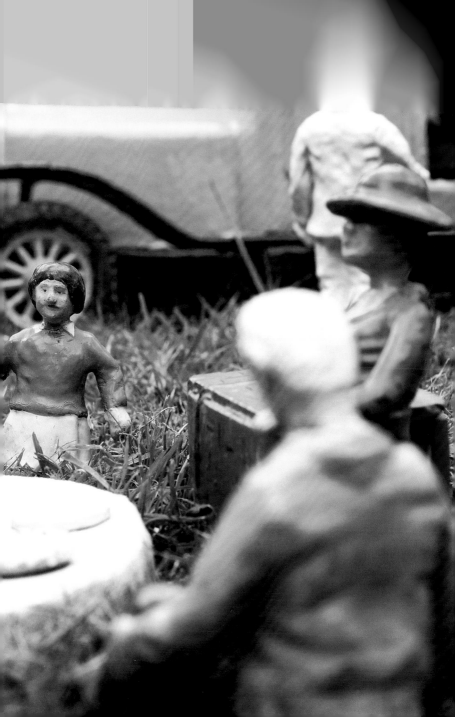

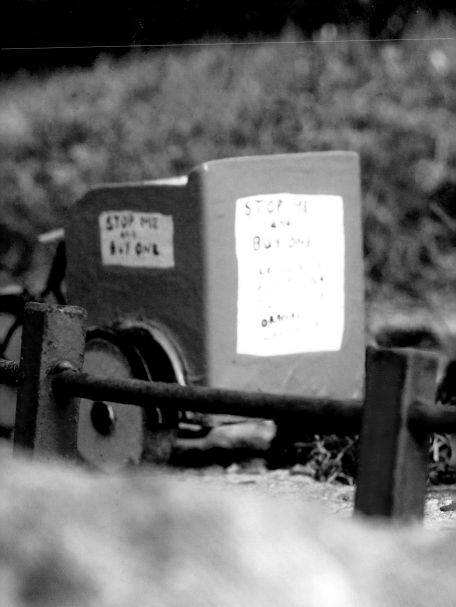

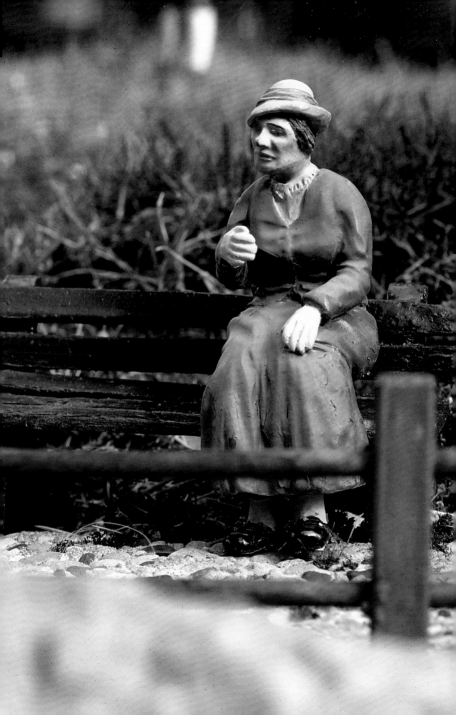

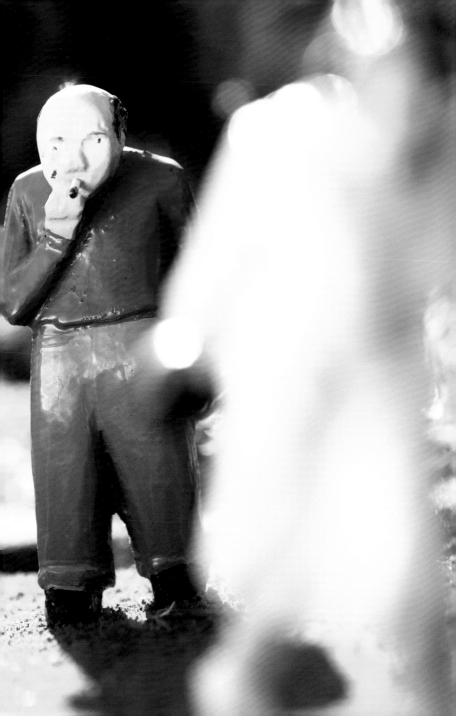

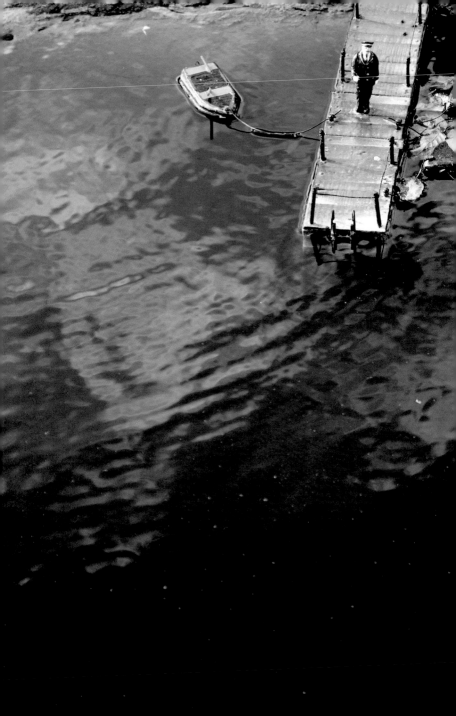

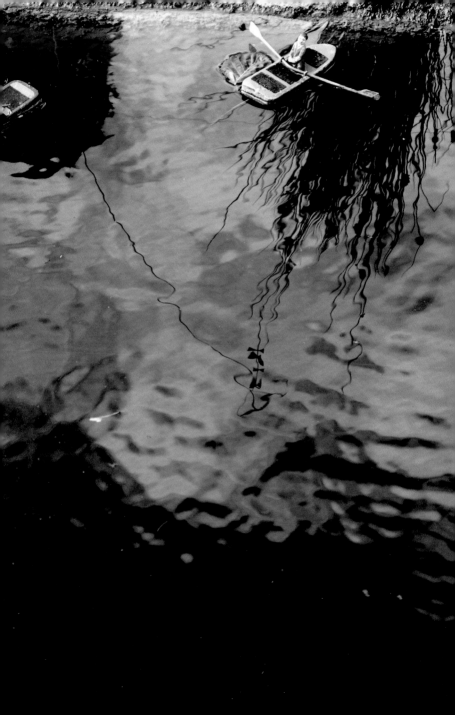

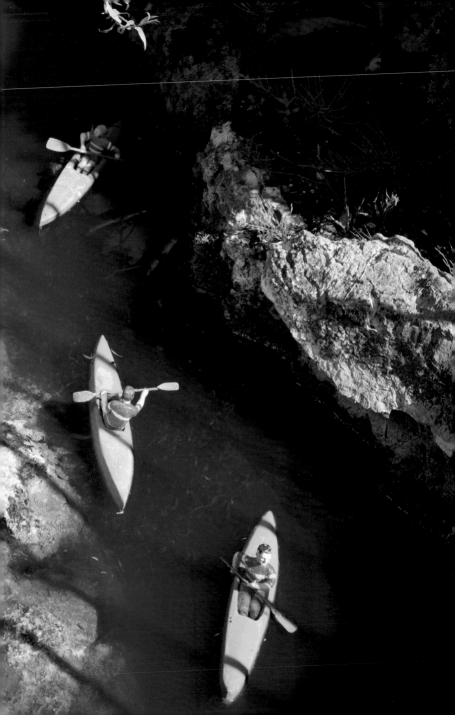

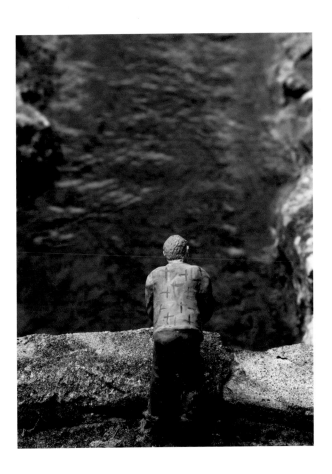

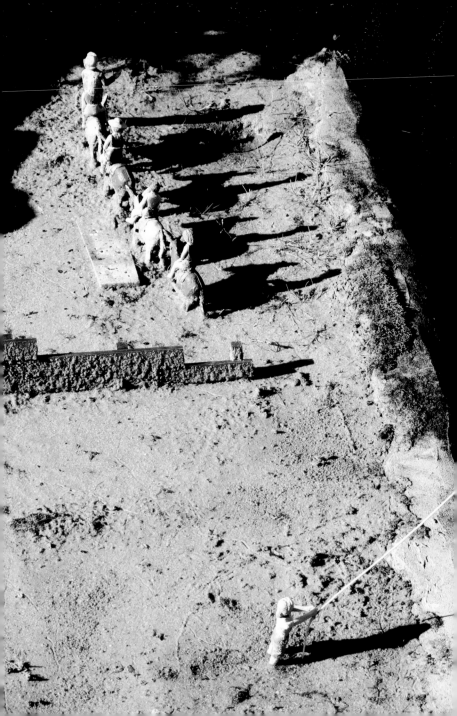

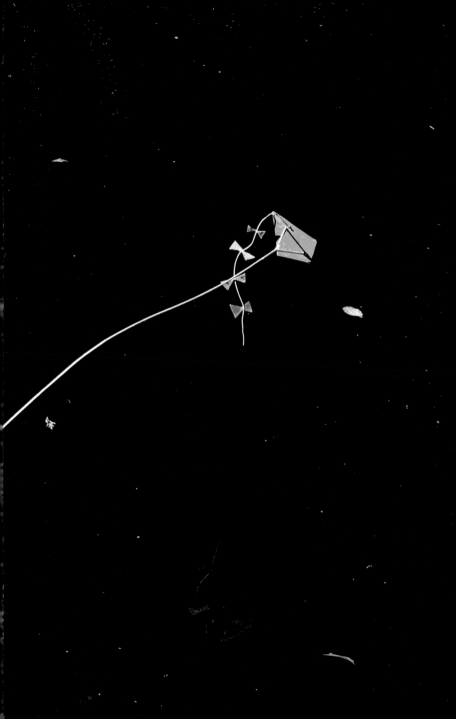

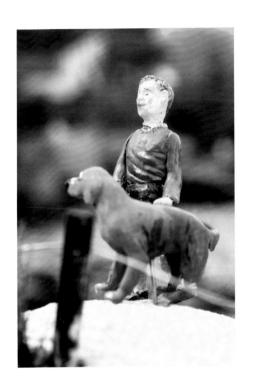

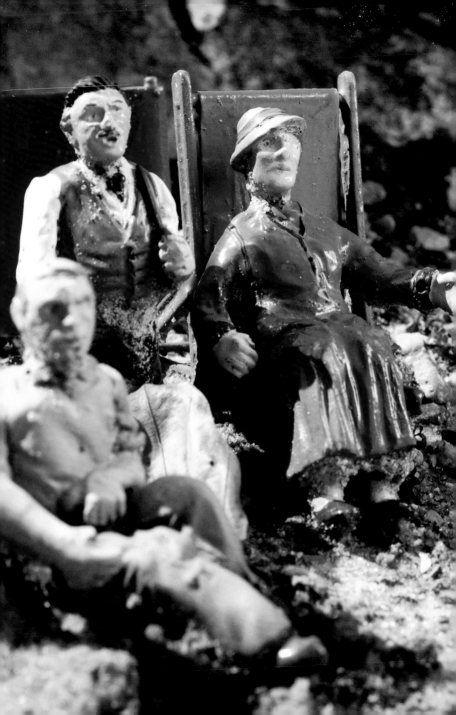

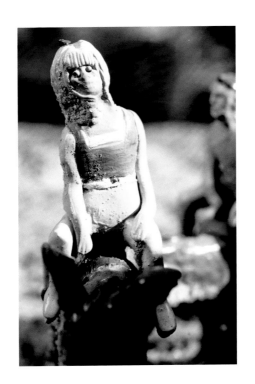

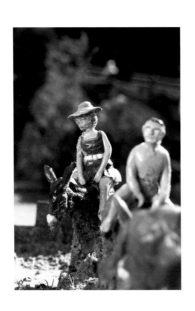
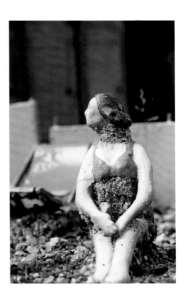

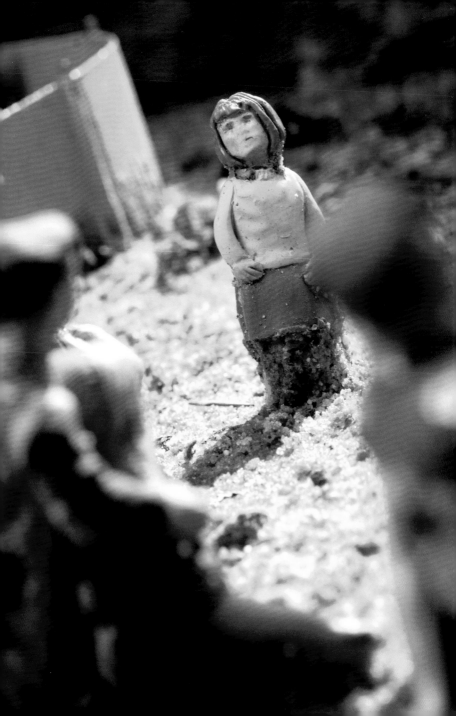

SPECIALS

PLAICE, CHIPS &
MUSHY PEAS
3d

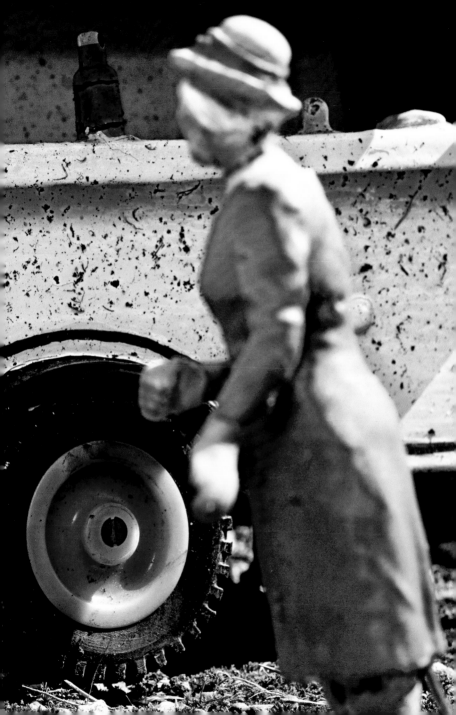

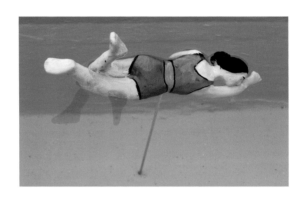

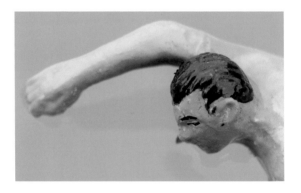

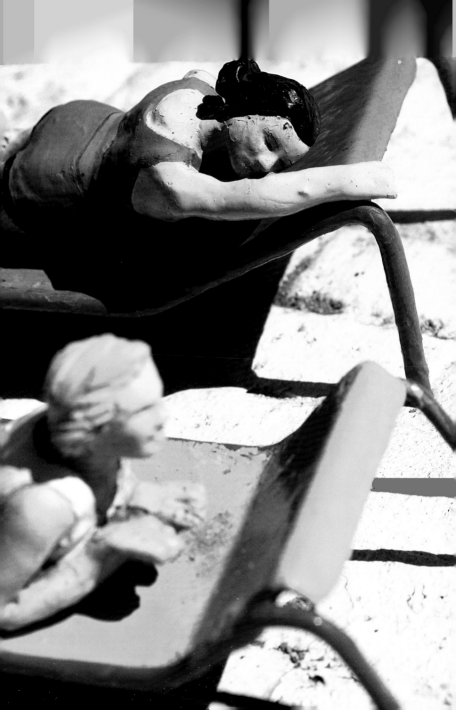

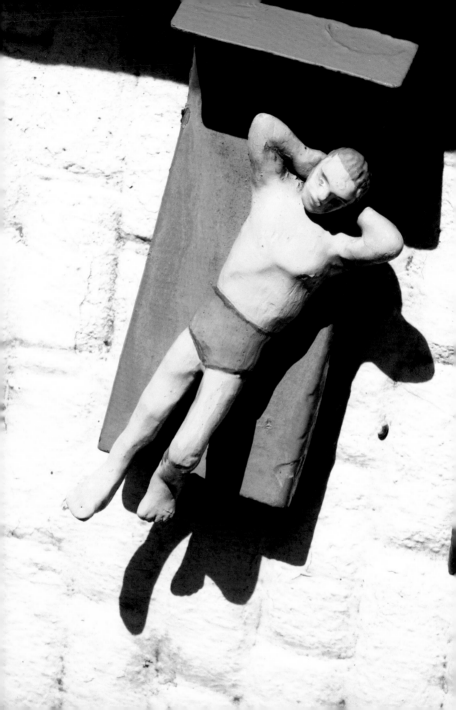

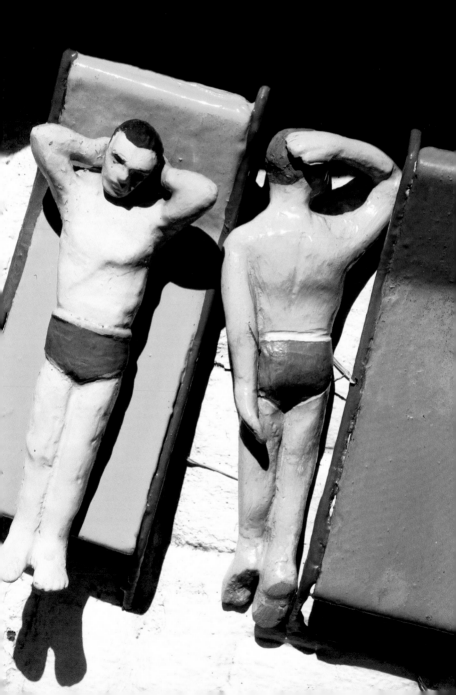

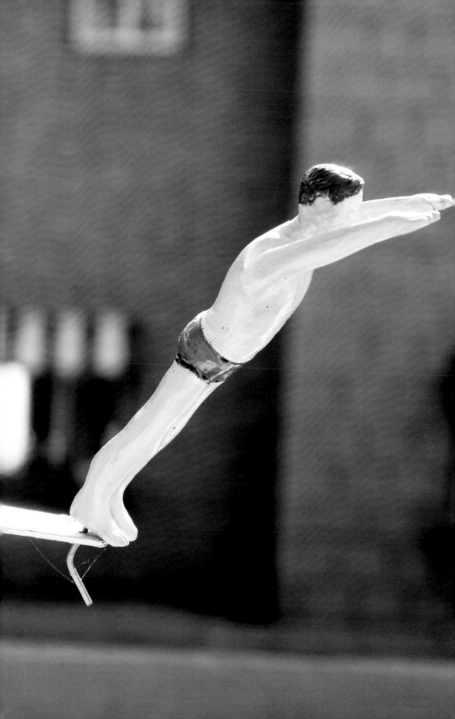

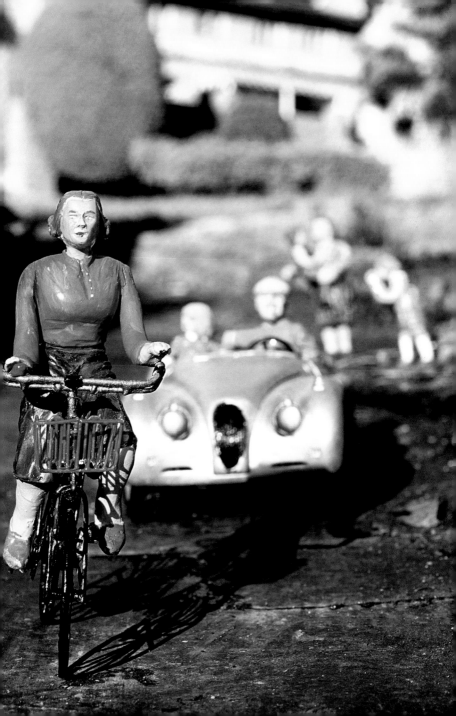

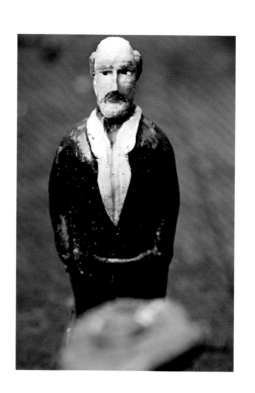

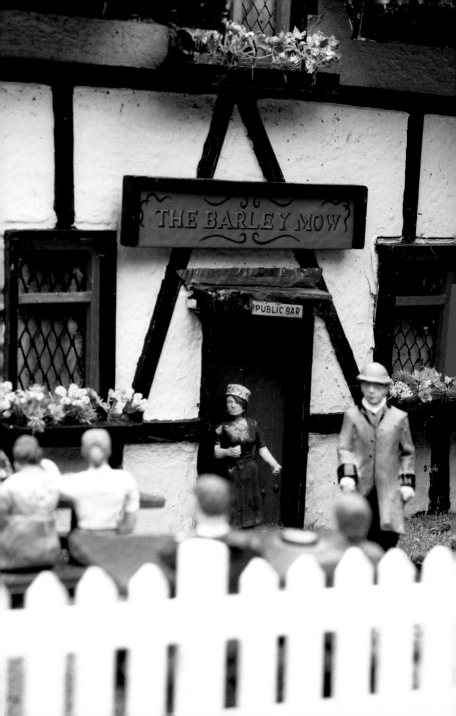

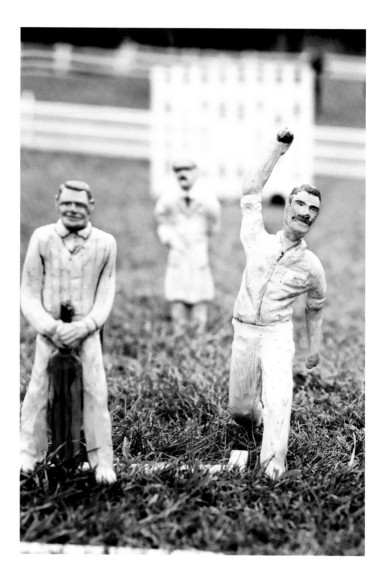

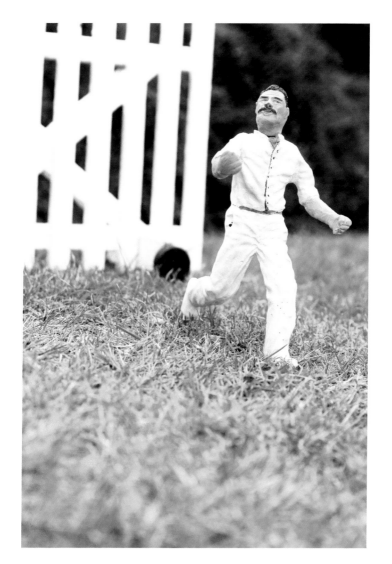

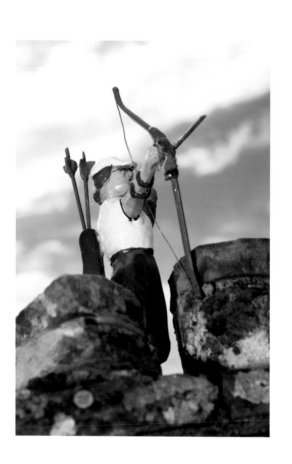

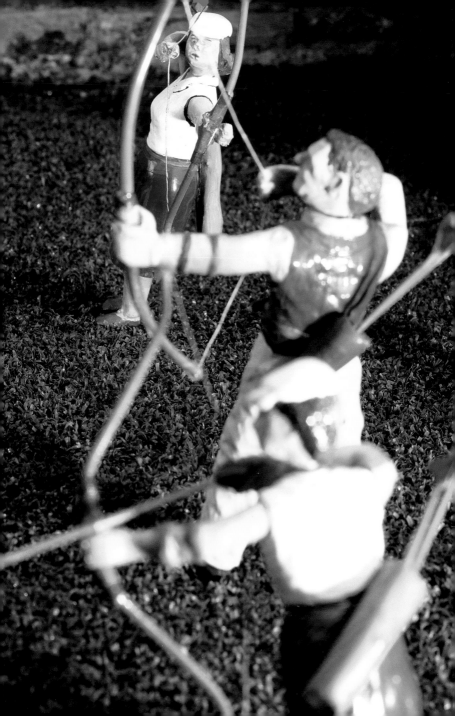

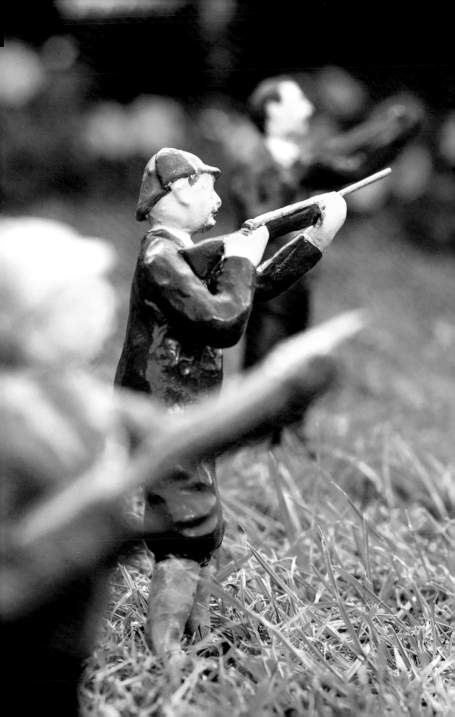

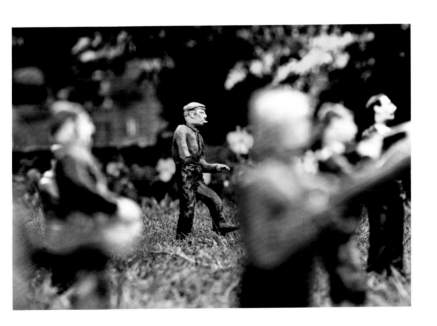

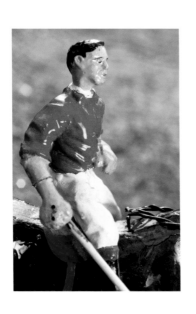
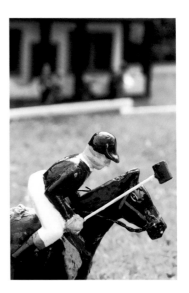

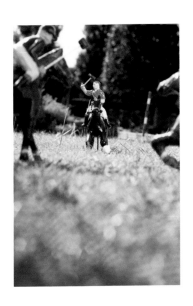 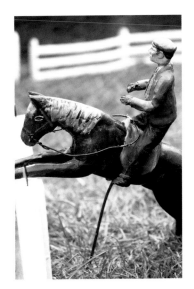

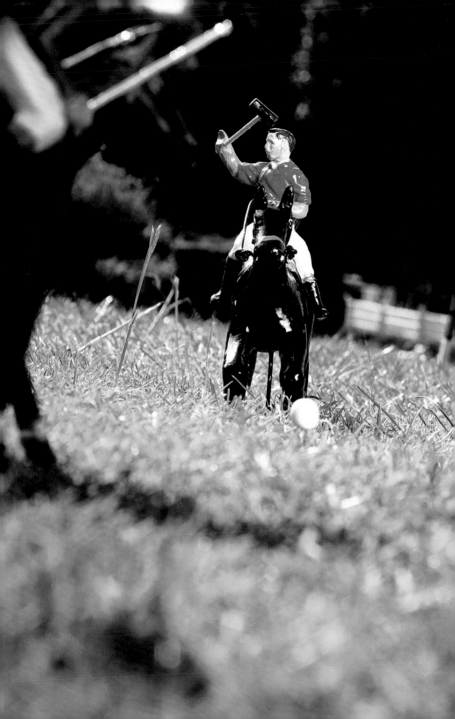

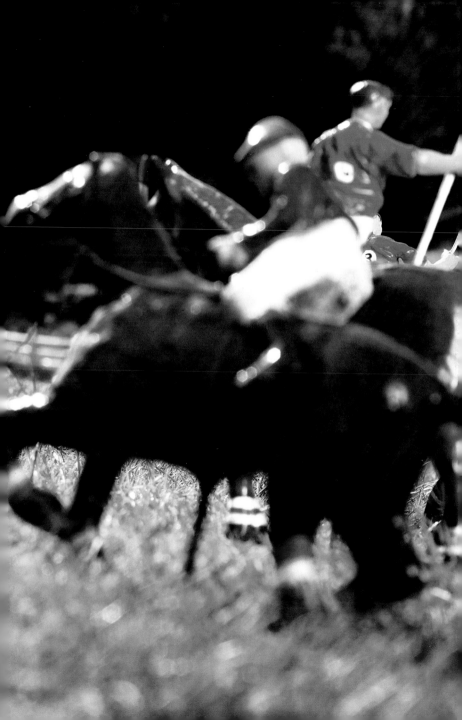

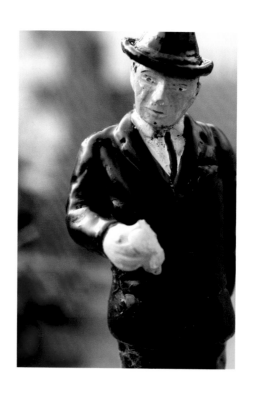

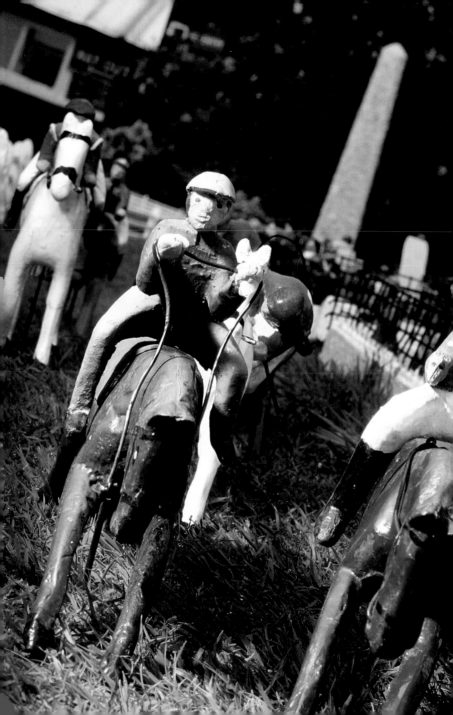

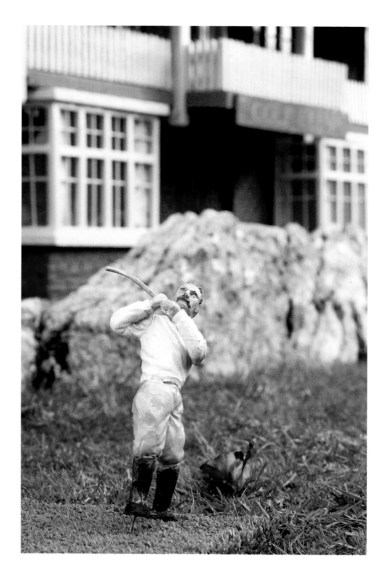

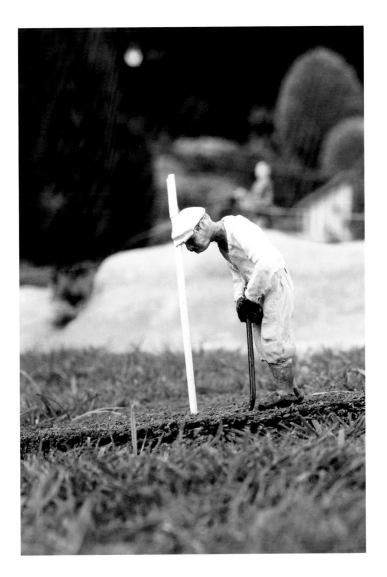

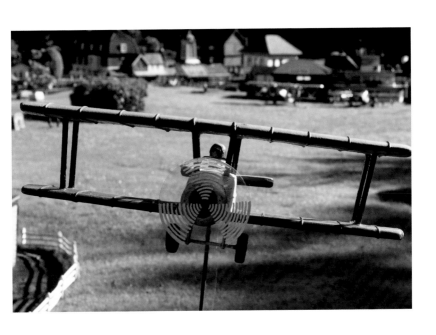

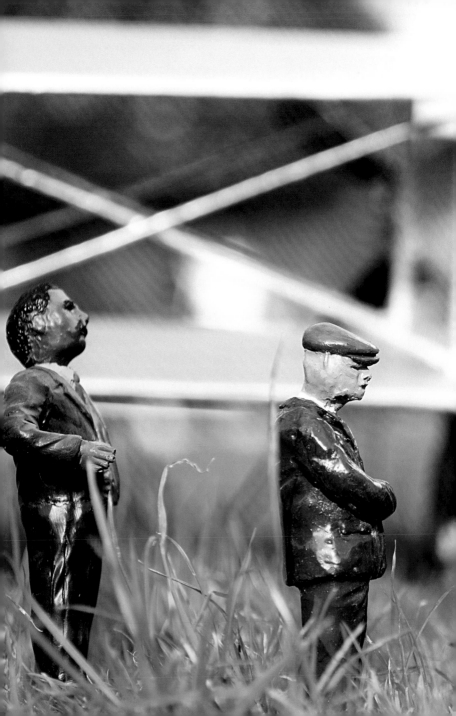

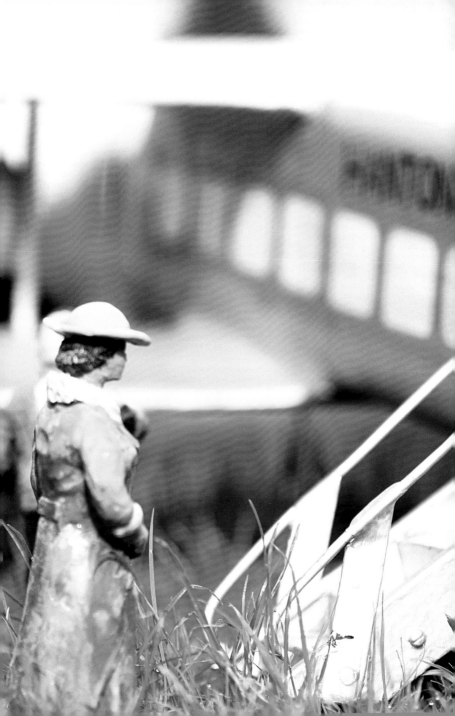

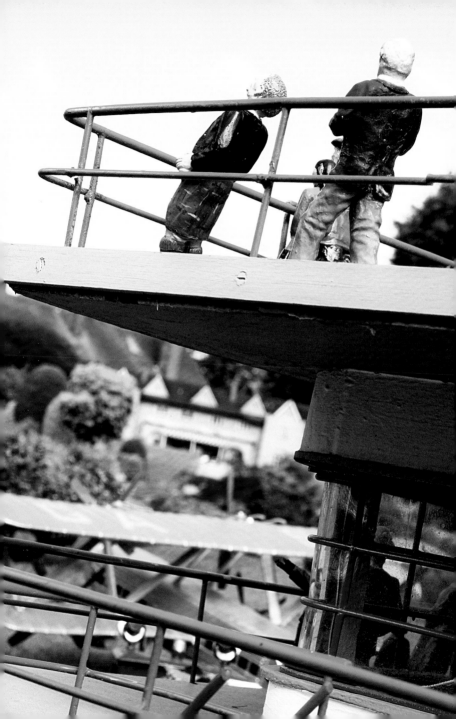

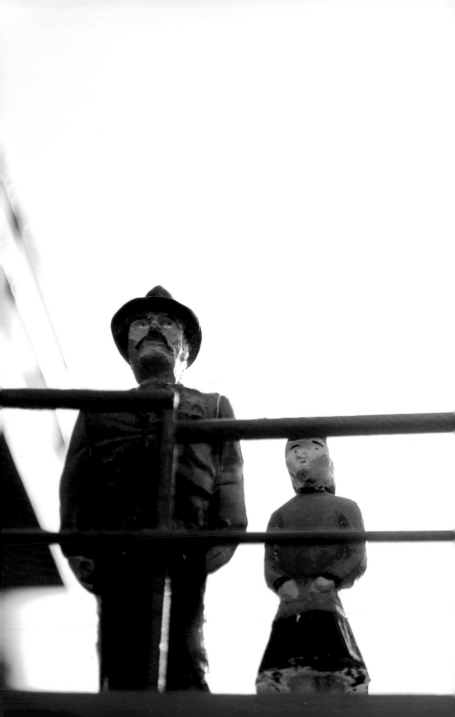

I would like to thank assistants Sofi Fransson, Eivind Vogel-Rodin, Joao Nogueira and Jorge Boleas for their production and lighting help; Brian, Sandra, Tim and Lauraine at Bekonscot Model Village for their unconditional practical support; Vahakn and Myrian Vorperian and Graeme Bulcraig at Touch for their generous help in the making of this book; Shirley Moore and Callum Bailey-Allen, the future of MV; Caroline Warhurst and Dewi Lewis for seeing this idea so clearly and following it through so thoughtfully; and lastly Ally Ireson whose unstinting support and affection for Bekonscot Model village is matched only by mine.

Liam Bailey

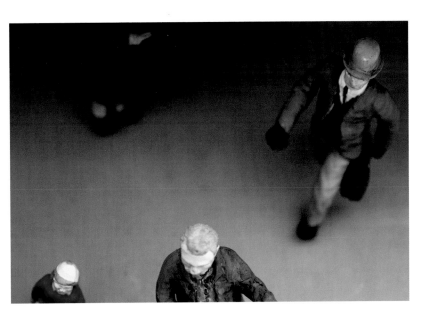